AFRICAN
APPAREL

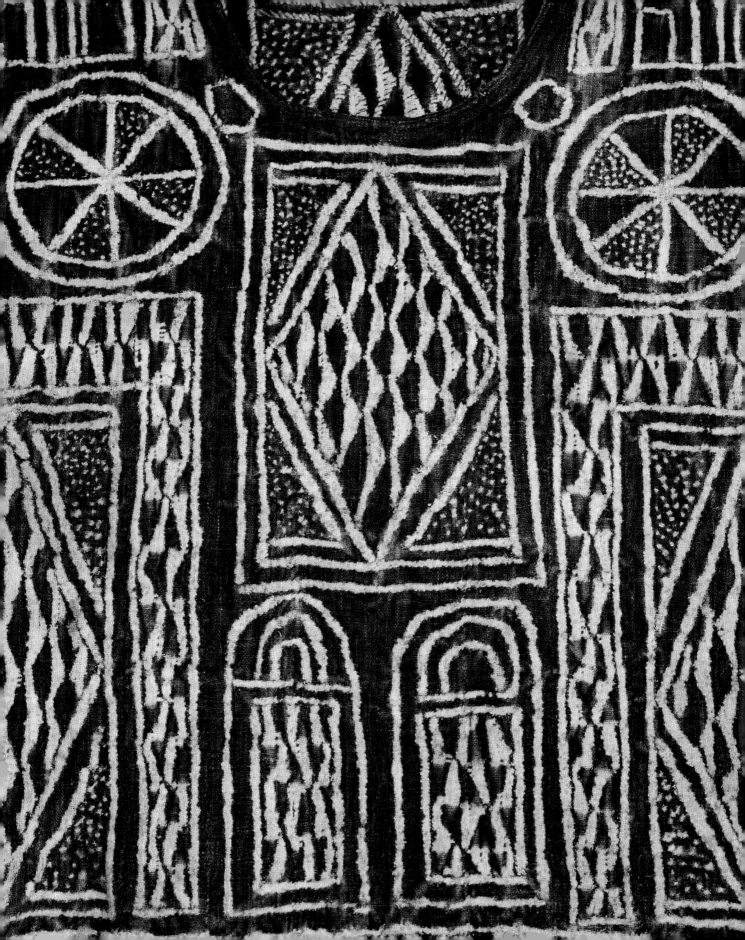

AFRICAN APPAREL

Threaded Transformations across the 20th Century

MACKENZIE MOON RYAN

Cornell Fine Arts Museum, Rollins College
in association with Scala Arts Publishers, Inc.

Text and photography © 2020
Cornell Fine Arts Museum, Rollins College

Book © 2020 Scala Arts Publishers, Inc.

First published in 2020 by
Scala Arts Publishers, Inc.
c/o CohnReznick LLP
1301 Avenue of the Americas
10th floor
New York, NY 10019
www.scalapublishers.com
Scala – New York – London

Distributed outside of the
Cornell Fine Arts Museum,
Rollins College, in the book trade by
ACC Art Books
6 West 18th Street
Suite 4B
New York, NY 10011

ISBN 978-1-78551-263-6

Cataloging-in-Publication data is
available from the Library of Congress.

Edited by Magda Nakassis
Designed by Studio A, Alexandria, VA
Photography by Pixel Acuity, Florida
Printed and bound in India

10 9 8 7 6 5 4 3 2 1

Frontispiece:
Resist-dyed indigo tunic (detail)
Bamileke
Cameroon
(cat. 11)

Page 5:
Metal filigree bracelet
Fon
Republic of Benin
(cat. 43)

Front cover:
Beaded shirt (detail)
Bamileke
Cameroon
(cat. 13)

Back cover:
Silver cross pendants
Ethiopia
(cat. 17)

Contents

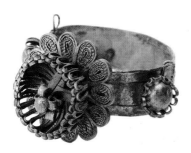

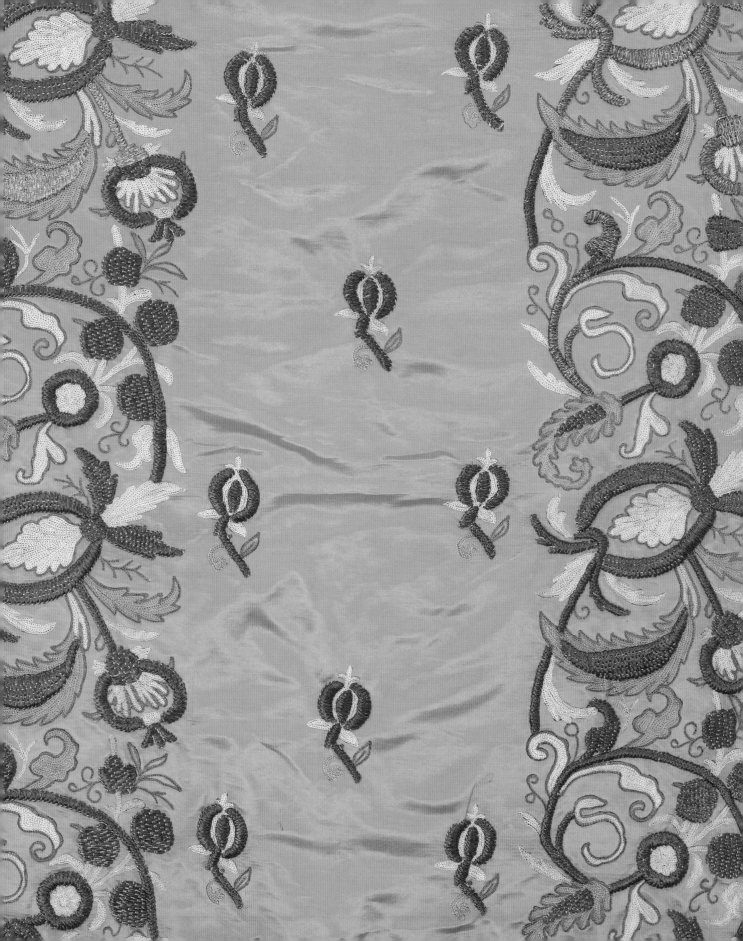

Director's Foreword

Art—we are poignantly reminded by this book and the exhibition it accompanies—inspires through color and form, materiality and composition, geometry and texture, and beauty. The beaded bags and woven cloths; the necklaces, collars, and pectoral crosses; and the ceremonial headgear and dresses in *African Apparel: Threaded Transformations across the 20th Century* display an explosion of color and a universe of skill. Yet art, and especially the art in this exhibition, is so much more. These objects were made to be worn proudly; to signal belonging to a group, a family, a region; to negotiate religious or life-cycle rituals. As observers in the twenty-first century, we learn through these works about more than the time and place they were made, and the ways in which they functioned. We learn about symbolism and beliefs, generational conflicts and continuity, gender and relationships, and global interactions.

The complexity of connecting these various narrative and symbolic threads in an exhibition that is at once serious and joyous, scholarly and approachable, was skillfully navigated by Dr. MacKenzie Moon Ryan, associate professor of art history at Rollins College. We owe this exhibition and book to Professor Ryan's expertise and thorough research, as well as to her unwavering passion for teaching. With the help of the Rollins Student-Faculty Collaborative Scholarship Program, she fully engaged Rollins students Morgan Snoap '20 and Cristina Toppin '21 into the making of the exhibition. Alongside Professor Ryan, they learned in action—the best way to observe, research, handle, and contextualize art. I am thankful to all of them for this unique exhibition.

The team at the Cornell Fine Arts Museum took the idea and transformed it into a spectacular exhibition. My gratitude goes to Austin Reeves for overseeing all in-house aspects of the catalog production, as well as exhibition logistics; to Adam Lavigne and the art-handling team for the skillful installation; to Gisela Carbonell, Elizabeth Coulter, and Louise Buyo for complementing the exhibition with engaging programming; and to Dana Thomas, Dina Mack, and Hind Berji for involving the community through marketing, advertising, and collaborative outreach. Special thanks to the team at Pixel Acuity for the masterful photography and to our partners at Scala Arts Publishers, Inc., led by Jennifer Norman, for this beautiful catalog. Our work was much facilitated—indeed, the exhibition was made possible—by the sponsorship of board member and indefatigable CFAM advocate June Nelson, and Nelson Financial Services. We are deeply thankful for June's generosity, her love of Africa, art, and our museum.

Last, but certainly not least, my deepest thanks go to Norma Canelas Roth (Rollins Class of 1965) and William Roth. This exhibition would not exist without their lifelong passion for collecting, combined with a thirst for knowledge and a nuanced understanding of the cultures and societies behind the art. We are grateful for their willingness to share this part of their collection with our community, and for Norma's visible enthusiasm for sharing her extensive knowledge of African dress to future graduates of Rollins College. This exhibition and catalog—embodying our museum's teaching mission—are a testament to Norma Canelas Roth's commitment to learn and share learning.

Ena Heller
Bruce A. Beal Director,
Cornell Fine Arts Museum

Silk wrap (detail), Fès, Morocco (cat. 1)

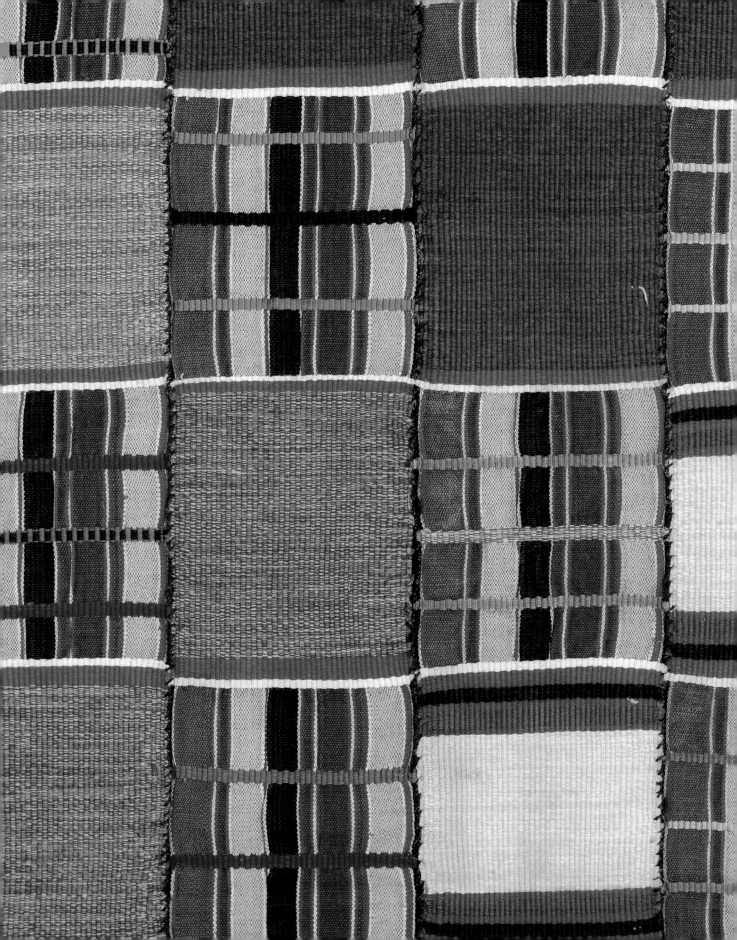

Curator's Acknowledgments

This project would not have been possible without my close collaborators, Morgan Snoap '20 and Cristina Toppin '21. We embarked on the creation of *African Apparel* together, and they have been integral to every decision from naming the exhibition, devising themes, selecting artworks for inclusion, researching, writing, editing, measuring, packing, to planning the gallery installation. They rose to every challenge, and were cheerful and professional partners in this exhibition and its accompanying catalog.

This catalog and the exhibition it accompanies of African dress, textiles, and jewelry is almost wholly drawn from the spectacular collection of Norma and Bill Roth, but their involvement has meant much more than lending artworks. Norma's keen eye, incredible memory, and deep respect for artistic traditions—especially those once worn, loved, and treasured by their makers and users—inspired and guided the exhibition in its formation. Through our visits and our lunches, Morgan, Cristina, and I feel privileged to call Norma and Bill friends.

I would also like to thank the staff at the Cornell Fine Arts Museum (CFAM), especially Ena Heller, Bruce A. Beal Director, for inviting me to curate an exhibition and supporting my desire to include students at every turn. Austin Reeves, collections and exhibitions manager, ably handled both exhibition and catalog logistics and Adam Lavigne, chief preparator, ensured the spectacular gallery installation.

Generous exhibition support came from CFAM and the Student-Faculty Collaborative Scholarship Program, made possible by the Elizabeth Morse Genius Foundation, Office of the Dean of the College of Liberal Arts at Rollins College, Clint Foundation, and Edward W. and Stella C. Van Houten Memorial Fund. The Samuel P. Harn Museum of Art at the University of Florida and Nancy Decker, associate professor of German at Rollins College, also lent textiles to the exhibition.

I owe a great debt to Mr. Ukera K. and Mrs. Zakiya Peera, and the late Mr. K. G. Peera, for profoundly impacting my research on *kanga* cloth. To my colleagues in the Department of Art and Art History for shepherding me in my formative years as a professor. To my editor and friend, Sarah Fee, curator of Eastern Hemisphere Textiles and Fashion at the Royal Ontario Museum in Toronto, for always turning a critical eye to my writing and providing a supportive voice. To my graduate school mentors at the University of Florida—Robin Poynor, professor emeritus; Susan Cooksey, curator of African art; and Victoria L. Rovine, professor of African art at the University of North Carolina at Chapel Hill—for developing me as a young scholar. To my undergraduate mentors in London, John Picton, emeritus professor of African art, and Charles Gore, senior lecturer in the history of African art, at the School of Oriental and African Studies, University of London, for expanding my understanding of African art.

And to my first professor of African art, Leonardo Lasansky, professor emeritus of studio arts, Hamline University, who introduced me to the subject, who first involved me in the creation of not one but two exhibitions, and who enabled my first publication. The entire experience of curating exhibitions and working with artworks firsthand has led to my commitment to do the same for the next generation. Thank you for setting me on this path.

Finally, to my husband, James, and our daughter, Imogen, without whom none of the hard work would mean half as much.

MacKenzie Moon Ryan
Guest Curator, Associate Professor of Art History, Rollins College

Kente cloth (detail), Ewe, Ghana (cat. 40)

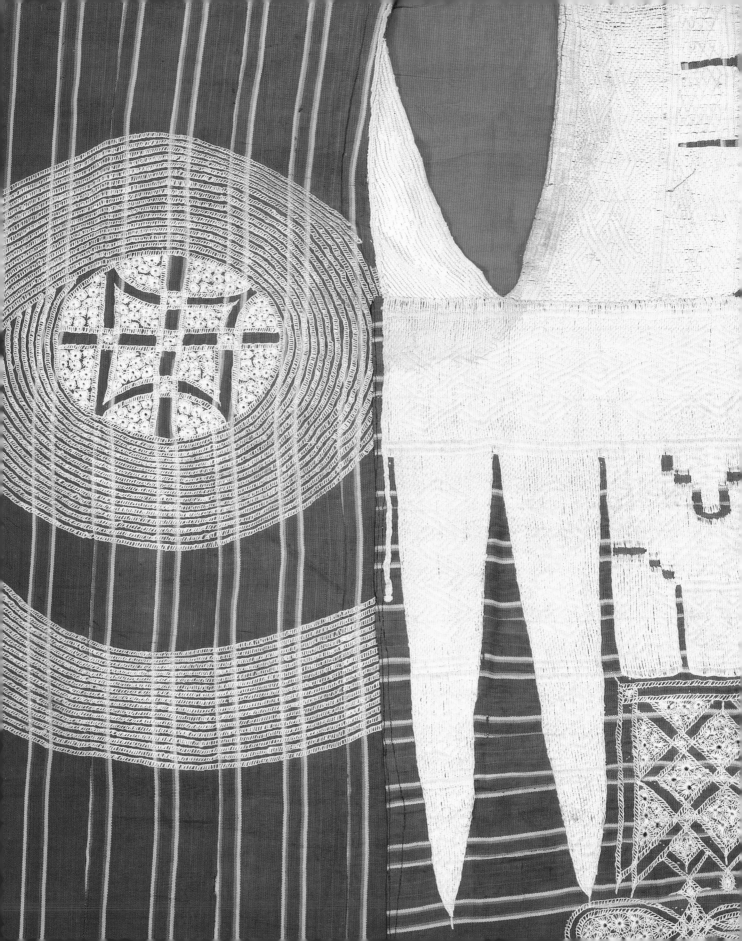

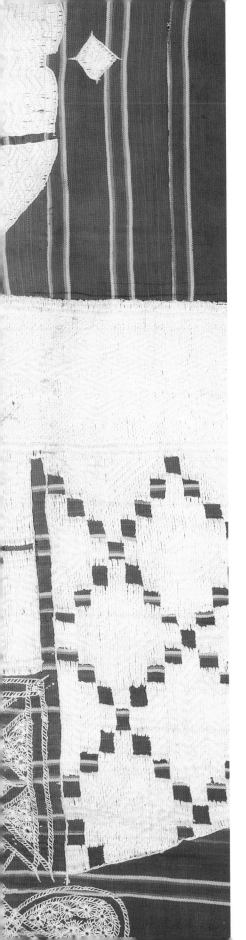

Conversation between Collector and Curator

Norma Canelas Roth, Rollins Class of 1965, collector

MacKenzie Moon Ryan, associate professor of art history, Rollins College, and curator of *African Apparel: Threaded Transformations across the 20th Century*

RYAN Why did you say yes to this project, *African Apparel: Threaded Transformations across the 20th Century*?

ROTH Most of all, I went to Rollins, and I remember my years at Rollins with great affection. And it was because of Rollins that I became an art historian, so it all seemed to make sense.

RYAN Can you tell us a little bit about your collection, how you collect, what you collect—a quick overview of who you are and what you do?

ROTH I have always collected. It's part of who I am and what I am. I collect. And as a child, we lived by the ocean and I collected seashells. It has always been something I did. I loved art. I always loved painting and making things, so it was only natural that I would study art in school.

Originally, I had planned just to study fine art. I never planned to be involved with art history because, frankly, going from a regular painting class to one of those sessions where you look at old paintings was so boring that I would almost fall asleep. So, I didn't want to take art history, but my adviser said I had to, so I thought that I might as well get it over with. So, my sophomore year, I took my first art history class. And it was a young professor, he was the most

enthusiastic, brilliant professor, he would get so excited he would trip over his lectern, and it was contagious, his enthusiasm, it just absolutely made me enamored of the subject.

I fell in love with art history, it was addictive. After that I could not wait to take more art history classes, and it just became a way of life for me. I have loved the arts with passion ever since. So, when Bill and I married, it was natural that we would continue collecting. Because I have always collected, and he and I started collecting together.

Bill had never collected art but he was a natural. So, we became a perfect pair and we both started going to galleries and auctions, and our collection evolved from prints to contemporary art, and from that, we eventually collected art that I had never studied: art from other cultures. The art of Africa, Asia, South America, ethnographic. And it became a learning endeavor that has become an ongoing passion all my life. I have had to learn in order to collect because these are not things that we were taught in school. I fell in love with textiles, which I knew nothing about. It is the kind of thing that the more you discover, the more you love. The more you find, the more there is to find. It's an ongoing love affair that has

Red *riga* (detail), Hausa, Nigeria (cat. 42)

no end. Our collection has been this love affair that has grown and expanded and been the most exciting thing we have done in our life.

RYAN What for you brings the collection together? Where is the center, the beating heart?

ROTH Connectivity. Everything has a connection. And this is what makes it so incredibly interesting: that other cultures are not that dissimilar from our own. We started out collecting contemporary art, the art of the '70s and early '80s when the Pattern and Decoration (P&D) artists were exploring other cultures and making it their own, making it into contemporary art. And as we got to know these contemporary artists, we were interested in what inspired them. Their inspiration came from other cultures and from the decorative, things around us that we weren't used to looking at, like quilts, handmade objects, wallpaper, textiles. Some of them were using things from other cultures, from Japan, from India, from Tibet, North Africa, the Middle East, South America, Mexico. The artists had traveled and they had found elements of these cultures that excited them and had incorporated these elements into their work. Because we loved their work, we became interested in the things that had inspired them. That created a connection for us to learn, and these connections are there not just for those particular people, but for all people. This has been the most fascinating thing that I have learned and that I have had as my inspiration throughout the time that we have collected. People have developed these ideas over thousands of years, these same ideas have been developed in unique ways, but they are still there if you look for them.

RYAN You sound to me less like a collector and more like a scholar, more like a sensitive citizen of the world.

ROTH It's all the same thing, and I think what is so important about collecting is that we have been fortunate enough to assemble things that we think are truly important and unique, many of which are fragile, and we hope that they can be preserved and that they will have a continued life that others can learn from.

RYAN So, you are a steward for the future of many of these objects.

ROTH Very much so. Because there is so much that I don't have the time or the opportunity to learn as much as I need to, so I am hoping that someone else will.

RYAN That brings us to a nice segue to talk about students and education and how this project has involved students—

ROTH —which I've loved—

RYAN —from the outset. Can you tell us a bit about your perception and perspective on involving students?

ROTH Well, when you told me that you were going to include some of your students, I thought that was really exciting and of course I didn't know what that meant exactly, but you brought two of the most amazing young women I have met. Not only are they smart, but energetic and eager to learn. They have been a delight to work with, and it has been a very fulfilling and rewarding project for me.

If there could be more projects done to bring students into the mix, it would be a wonderful way for education to leap forward because I feel that these young women have taken it and they've run with it on their own. I am amazed.

RYAN Do you think this catalog will help share this collaborative work?

ROTH You never know what's going to be here for the rest of us to be able to use in the future. That's why you do the best that you can: because you might reach one person. I really believe if you can reach one person, you can make all the difference in the world.

RYAN For this exhibition, which is based primarily on Africa, on African textiles and adornments, what do you think might be the transformative aspect, for the general public, for students?

ROTH I hope that you could get students to attend: that is the advantage that any college or university museum has, that it can reach students. There is always an opportunity to reach one individual who has a creative spirit that hasn't yet been touched. And you might have the opportunity to reach that one person.

RYAN The whole of this exhibition is made up of items that were once someone's, someone's personal clothing, their heirlooms, their treasures. Talk a little about the difference you see in definitions of art that solely hang on the wall versus these objects that were created to be touched, loved, and worn?

ROTH It is art, it was made by humans one piece at a time, much of it is creative, unique, and it is part of treasured objects from a society's culture. Many of these objects are held in great respect by that particular society. Not as adornment, but as status objects. These are oftentimes passed down from one generation to the next, not discarded. A lot of the sculpture that we find so important from the same societies is made for ceremonies, and after being used it is discarded, whereas these items were not. They are treasured and have great dignity and great value to individuals in those particular cultures.

They make each piece by hand; it may take weeks to make one piece. If it is a beadwork piece, each is sewn by hand. They are not cheap craft beads like we see today, because they had a total different value structure. It is hard for us, with our Western perspective, to look at these pieces and recognize them for what they are, or were. The designs just came forth from the individual—I just find that mesmerizing. I can't imagine it.

RYAN What, from your perspective, has been the best aspect of this project?

ROTH It has been working with the students. That has been so much fun; I have enjoyed it thoroughly. It has been fun opening boxes, finding things I haven't seen in years, and noting their reaction to pieces, because sometimes they would be really excited, and sometimes they would be like, "Another one of those?"

Winter Haven, Florida
January 4, 2019

Ivory ring, Dinka, South Sudan (cat. 28)

"[These items] are treasured and have great dignity and great value to individuals in those particular cultures."

NORMA CANELAS ROTH

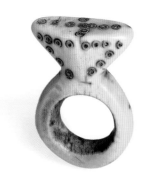

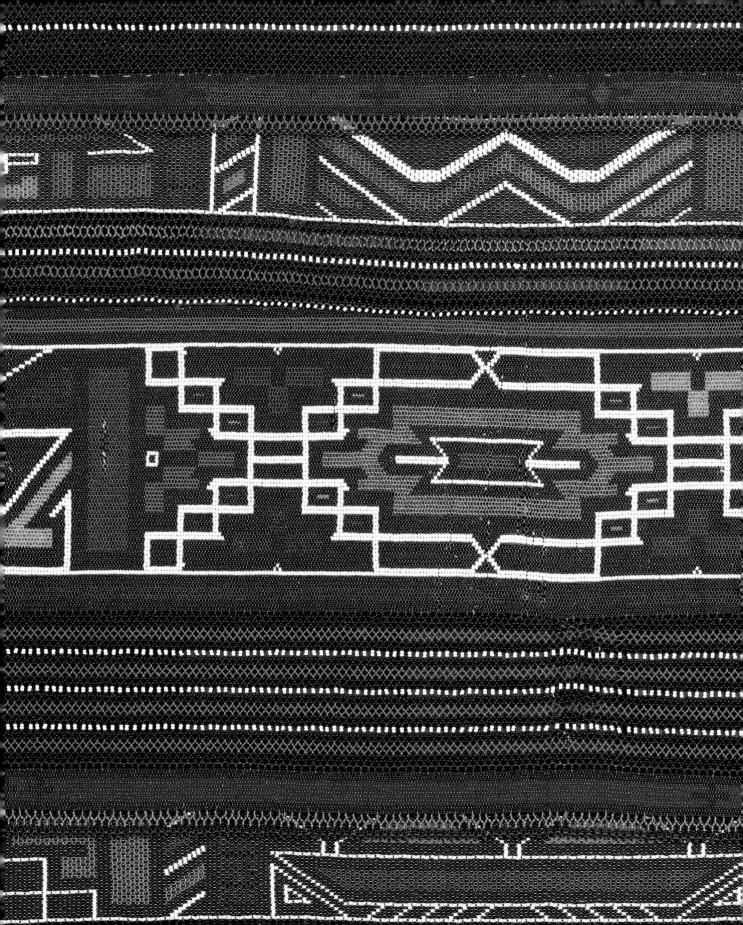

The Artistry of African Apparel: Global Interactions, Gendered Realities, and Generational Conflicts and Continuities

MacKenzie Moon Ryan

What people wear is deeply personal. It is also enormously impacted by historical, cultural, religious, and political realities, which change over time. As worn garments, these items of apparel are loved, lived in, labored over, and invested with salient meaning. While any attempt to display the breadth, diversity, and artistry of a continent is an impossible task, this catalog and its related exhibition attempt to highlight a few dozen transformations in African apparel across the twentieth century. Without question, these textile, jewelry, headwear, accessory, and clothing items highlight their indebtedness to global interactions, their embodiment of gendered realities, and their expression of generational conflicts and continuities.

Marriage blanket (detail), Ndebele, South Africa (cat. 36)

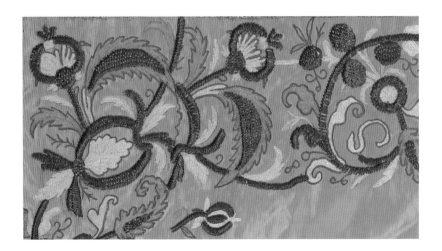

FIG. 1 (above right) Silk wrap (detail),
Fès, Morocco (cat. 1)

FIG. 2 (below) Beaded headband (detail),
Kuba, Democratic Republic of the Congo
(cat. 34)

Sometimes the continent of Africa is presented as monolithic and unchanging, as if there is one African culture, language, or lived experience. In reality, Africa is huge, diverse, and populous, so much so that its facts are hard to conceptualize at times. Nevertheless, a few help us to contemplate Africa's enormity. It is the second-largest continent and second most populous, after Asia. Geographically, it is four times as large as the contiguous United States. Africa comprises fifty-four independent countries and one disputed territory. Africans, some 1.28 billion people, speak an estimated 1,500 to 2,000 individual languages. The principle languages of Arabic, English, and French illustrate a history of global forces and formal colonization across the continent, but all fifty-four countries list multiple official or national languages. The African languages of Swahili, Amharic, Yoruba, Oromo, Hausa, and Zulu constitute just some of the lingua francas across the continent. While this catalog comprises fifty-four entries, it is by no means representative of every country, nor could any such publication of similar scale claim to be. What this catalog attempts to do, however, is introduce readers to the enormous variety, complexity, and diversity of African dress traditions, which themselves have changed markedly across the twentieth century.

Notably, African apparel is presented here from not only West Africa, but also Central, Southern, East, and North Africa. At times sub-Saharan Africa is presented as Africa, cutting off North Africa at the Sahara Desert and treating it as part of the Middle East. This catalog instead presents clothing and adornment from the entire continent. It embraces globally influenced dress practices as a reality across Africa. From North Africa, silk clothing from Fès, Morocco, provides but one example of how Jewish, Islamic, and European influences coalesced to form unique, urban silk textile traditions. The centuries-long interaction with the Mediterranean world, including the Iberian Peninsula as well as the Middle East, imparted influences in designs, technologies, and aesthetics that characterize the silk wrap with metal

and silk embroidered designs (Fig. 1) in this catalog. Across the continent, accessories such as the Kuba beaded headband (Fig. 2) from the present-day Democratic Republic of the Congo incorporate cowrie shells from the Indian Ocean, spanning a distance of at least 1,600 miles.

The continent of Africa is extremely diverse in its cultural traditions. Although Africa is often glossed as unchanging or unwittingly presented as backward, faraway, and unknown, this catalog aims to demystify conceptions of Africa and engage readers in perhaps lesser-known realities. These garments, formerly owned, worn, and loved by Africans across the twentieth century, ask viewers to critically reflect upon what composes their mental picture of Africa. Beyond the media-driven reports of poverty, civil unrest, disease, and underdevelopment, readers may be familiar with potentially very little substantive information. Such reports perhaps give rise to a disproportionate view of Africa as unsophisticated, struggling, and in need of aid. By shedding light on positive attributes—how Africans have chosen to dress themselves, to display power, status, worldliness, and even trendiness—this publication seeks to replace negative stereotypes with affirming evidence of artistry, technical mastery, wealth, pride, and respect.

The majority of artworks included in this catalog are handmade: they are laboriously handwoven, individually dyed, embroidered stitch by stitch, beads threaded one by one. The technical mastery alongside the investment in both materials and in labor over the course of many hours, days, and weeks is overwhelming to contemplate. Designs may be the whims of an individual or, equally, multiple generations may impact a design and contribute to its creation. Some skills are passed down, mother to daughter, father to son, master to apprentice. Some are created through generational collaboration—grandmothers, aunts, mothers, and daughters may contribute to a single beaded item, as in the Ndebele wedding blanket, worn as a cape (Fig. 3), and the Maasai collar (Fig. 4), embodying continuities across generations.

FIG. 3 (above left) Marriage blanket (detail), Ndebele, South Africa (cat. 36)

FIG. 4 (below) Beaded collar, Maasai, Kenya or Tanzania (cat. 30)

FIG. 5 (above left) *Kanga* cloth with mosque (detail), Purchased Dar es Salaam, Tanzania (cat. 14)

FIG. 6 (above right) *Isishweshwe* cloth (detail), Purchased Cape Town, South Africa (cat. 18)

FIG. 7 (right) Fancy-print minidress, Owo, Nigeria (cat. 8)

The African continent and its billion-plus people have always been dynamic players in a globalized world. It should come as no surprise that the manufacture and consumption of industrially produced cloth and apparel has been a reality since the late eighteenth-century industrial revolution. In the nineteenth century, such new clothing options were highly sought-after and, by the twentieth century, synthetically dyed and industrially woven cloths were commonplace. While individuals displayed and continue to display their own preferences, regionally popular manufactured cloths show broad distinctions, upending expectations of a singular African demand writ large. *Kanga* (Fig. 5) of East Africa has a characteristic bordered design and Swahili phrase, while *isishweshwe* (Fig. 6) of Southern Africa more often displays repeating, allover patterns. Wax- and fancy-print cloth, popular across West and Central Africa, possesses layers of dye, pattern, and distinctive crackle, indicative of its global origins in Java, Indonesia. Even more apparent when tailored into an early 1970s minidress (Fig. 7) boasting a pattern of newly minted currency, industrially produced cloths are fascinating for their varied histories of development and wide adoption.

These more affordable cloths also shine light on a wider swath of people. Not everyone, nor of course the majority, can afford such hand-labored luxuries as presented in this catalog and in histories of African clothing traditions. So often in exhibitions of art, no matter the subject, media, or place and time, the artwork featured is only ever a reality for the extreme elite of a given society. As art history and museums turn to focus on the historically situated and culturally relevant, artworks that reflect broader populations, in socioeconomic status as well as geographic region, are imperative. These more affordable and more prevalent cloths, then, are the ubiquitous apparel in plain view but overlooked for decades.

Items of apparel are indicative of their unique moment in time, influenced by trends in color, design, and material. Sometimes this is constituted by the embrace of new materials, such as glass beads among young Dinka men in crafting their corsets (Fig. 8) of the late twentieth century. At times this marks a turn in user, patron, or intended audience, such as the Zulu plastic-coated telephone wire cap (Fig. 9) from South Africa which, while based on basketry forms, incorporates a new material from the 1980s intended for a different consumer. The period from the late nineteenth century to the present encompasses a great many changes in the everyday lives of Africans, to which they responded to, lived through, and defined with modes of dress.

Africa, like the entire globalized world, has experienced much change over the last century and a half. Generally, the era of formal European colonization, which directly affected all but one present-day nation, Ethiopia, dates from roughly the 1880s to the 1950s. During the colonial period, European nations drew lines on the map of Africa that roughly correspond to current national borders and codified their rule. The motivations for formal colonization were varied, but all colonies supplied industrialized nations with the raw materials to produce value-added and manufactured goods. From ivory piano keys and billiard balls to rubber for bicycle and automobile tires, to palm oil in soaps, cosmetics, and food, European nations and Euro-American consumers voraciously demanded and consumed African raw materials. Some colonies also provided opportunities for settlers, whereby Europeans emigrated to form new settler economies, where they were in the ascendency: European settlers owned land and generally had better opportunities than in their country of birth and as compared to their new African neighbors. Opportunities for Africans to rule themselves and advance were interrupted, minimized, or tightly controlled by European colonial powers during the first half of the twentieth century.

The majority of African nations declared their independence from European colonial powers beginning in the 1950s and continuing throughout the 1960s and 1970s, when new African states established democratic, military, capitalist, and socialist rule. An era of Pan-Africanism, burgeoning pride in African heritage, and enormous hope, this period saw the establishment of colleges and universities and the building of factories where the processing of raw materials into value-added goods could benefit new nation-states. Africans embraced globally circulating popular culture while leaders experimented with various trade agreements. Such agreements were often skewed to benefit the elites, leading to unrest, malcontent, and disquiet that marred the optimism of this era.

From the 1980s, many African nations chose to liberalize their economies, embracing wider integration into the global marketplace. The late twentieth century also saw the dismantling of apartheid laws in South Africa and the independence of Namibia and other proxy-ruled nations. The newest African nation, South Sudan, declared its independence in 2011. Fluctuations in currency values and limited or increased access to imported goods affected people's clothing practices, but the resiliency of cultural traditions mean that while visuals may change, Africans remain the inheritors of many generations of artistry and meaning.

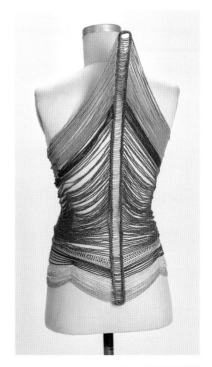

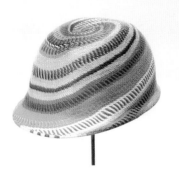

FIG. 8 Beaded corset, Dinka, South Sudan (cat. 29)

FIG. 9 Telephone wire cap, Zulu, South Africa (cat. 54)

Changes in political systems mark only one aspect of lived experience. Islam and Christianity have long played crucial roles in Africa, having been introduced to the continent within a century or so of each religion's founding. Nineteenth-century Islamic reform movements and increased Christian missionary efforts meant that both religions continued to play a defining role in Africans' lives across the continent in the twentieth century. Western-style education, implemented by colonial powers, led to marked changes in just two generations. And throughout the twentieth century, Africa's population has grown immensely, concomitant with a shift from largely rural societies to increased urbanization.

Mechanization, industrialization, and growing consumer cultures in many cases have shifted Africans to privilege the acquisition of many items of dress rather than heavily invest in fewer. But even so, dress practices continue to reveal personal and group identities, cultural traditions, religious associations, political affiliations, and aspirations across the African continent. This is to say nothing about the explosion in technology that better connects Africans to each other and to the wider world. Cell phones, satellite TV, and the internet, inclusive of social media platforms, increase the ability to share information quickly. Such technology is profoundly connecting and accelerating trends worldwide, especially in apparel. Many of these newest trends in clothing are driven by, for, and with Africans.

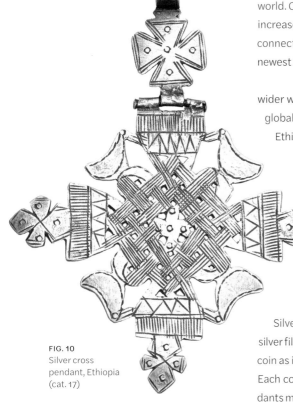

FIG. 10
Silver cross pendant, Ethiopia (cat. 17)

The continent of Africa has long demonstrated its involvement in the wider world but, in looking to individual articles of clothing and adornment, such global interactions are made plain. Silver cross pendants (Fig. 10), associated with Ethiopian Orthodox Christianity, embody a centuries-long tradition of Ethiopians proudly displaying their adherence to Christianity in the face of encroaching Islamic expansion across North and coastal East Africa. Ethiopia was among the first to embrace Christianity as its official religion in 330, not long after the Roman Empire. While the crosses share some similarities, each links to a historical precedent. For example, the largest cross, whose center is composed of interlacing designs with four birds, bears a design that dates to the reign of King Lalibela (r. ca. 1181–1221). Lalibela is famed for commissioning the construction of a collection of rock-hewn churches. Silversmiths used the lost-wax casting method for these silver pendants, with silver filigree added later, and after 1740 used the Maria Theresa silver thaler or dollar coin as its source.[1] No line is drawn between art, culture, adornment, or used object. Each concept flows readily into the next, making this selection of silver cross pendants much more than mere jewelry. They record historical interactions of world religions and serve as markers of identity, personal declarations of faith, and precious items of adornment—each commissioned, worn, and loved by an individual.

Indigo strip-weave cloth (Fig. 11), here from Ewe weavers in southern Ghana, suggests a West African–wide aesthetic, popular from Senegal to Nigeria. Historically, male weavers used horizontal looms to produce such strip-woven cloths for prestige clothing. Wearers generally wrapped the large, luxury cloths around

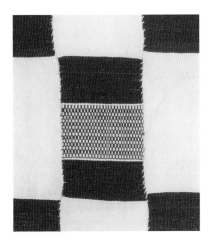

their bodies in order to visually command attention through their great size and expensive apparel. Additional heddles allowed master weavers to create supplementary weft float designs in the woven cloth, resulting in more complex, intricate, and sought-after designs. Similarly, natural indigo dye has long been highly prized across West Africa and beyond for its rich, dark, bluish-black color. Expert indigo dyers, from Wolof women in Senegal to the Hausa men of northern Nigeria, cultivated the Indigofera plant into dyestuffs, which was clearly superior to natural European woad. Only when Europeans devised synthetic dyes in the late nineteenth century did natural indigo production and dye begin to falter. The depth of blue, contrasting so starkly with unbleached cotton, effectively embodies this long-standing tradition of indigo strip-weave cloth.

Similarly, the Yoruba strip-woven cloth (Fig. 12) with aqua and yellow weft float designs on undyed cotton shows a blend of design influences and interactions. The small, arrow-like motifs at either end recall the top of carved wooden Koran boards. While the Yoruba live in southwestern Nigeria and are predominantly Christian themselves, they have long interacted with their neighbors to the north, the largely Muslim Hausa. Muslims across West Africa make use of wooden boards to practice writing passages from the Koran in Arabic, a method of memorization, prayer, and piety. The use of this motif, created from synthetically dyed aqua and yellow thread, shows the absorption of differing designs and adoption of new materials. A selection of cloths, jewelry, headwear, and accessories show how individual items of African apparel are themselves the products of global interactions, in design, motif, material, technology, and meaning.

Clothing in Africa is often the product of gendered labor and itself communicates gendered expectations and lived realities. The Imazighen, who reside across North Africa, understand weaving and personal adornment as highly gendered. Women are the weavers, using upright tapestry looms to symbolically give birth to their woven cloth, as in this Algerian wool shawl (Fig. 13). Their technical mastery of complex weaving techniques is matched only by their painstaking labor, which itself mirrors their life-giving ability to bear children.[2]

FIG. 11 Indigo strip-weave cloth (detail), Ewe, Ghana (cat. 5)

FIG. 12 Strip-weave with openwork cloth (detail), Yoruba, Nigeria (cat. 6)

FIG. 13 Wool shawl (detail), Imazighen, Algeria (cat. 23)

Equally, some items of apparel are conventionally linked to male power and authority. The Kongo chief's cap (Fig. 14) from the Democratic Republic of the Congo in Central Africa draws on a centuries-old convention of interlacing raffia to create this close-fitting cap. Such caps are presented to officials upon ascension into office. Historically reserved for men, women have also risen to high-ranking positions of authority and they too have earned the right to don such headwear. The cap's humble materials and delicate design demonstrate the balance, precision, and clear artistry of Kongo raffia cloth and clothing. Through visually understated means, the cap reflects its wearer's power and status within Kongo society. Often assumedly male, this cap outwardly proclaims the privilege and responsibilities bestowed upon the individual, regardless of gender.

African apparel can also be indicative of generational conflict and continuity, demonstrating change over time as well as the resilience of long-standing traditions. Beads are among the earliest-known forms of personal adornment and they continue to play dynamic roles in the lives of Africans, communicating information about identity, heritage, as well as both changing and continuous aesthetic ideals. Take for example ostrich eggshell beads, which are found in great quantities beginning circa twenty-five thousand years ago. Recently archaeologists dated hand-hewn San examples from circa sixty thousand years ago.[3] The San utilize a hunter-gatherer lifestyle across Southern Africa and are the region's first people, where they have lived for tens of thousands of years. The San ostrich eggshell beaded necklace (Fig. 15) in this catalog, though certainly more recent, offers an example of the continuation of an artistic tradition—the desire to adorn oneself using items fashioned by hand—that spans millennia.

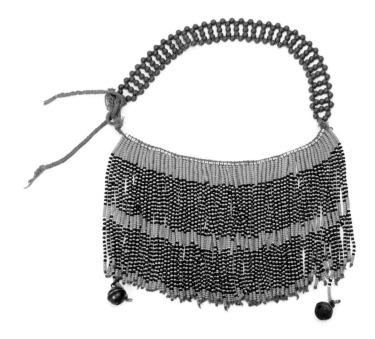

A similar example, but showing innovations in the recent past, comes in the form of glass and plastic beads, which together with imported metal bells compose a beaded apron. The Bhaca are linked to the Xhosa and live near the Zulu, and like many people in South Africa adorn themselves in threaded beaded attire. Composed of yellow, blue, and white glass seed beads, this beaded apron (Fig. 16) demonstrates how traditions of personal adornment change to accommodate access to new materials. European traders, then settlers, brought these commodities when they arrived to Southern Africa in the sixteenth century. Prices of beads came down in the nineteenth century and their volume increased in the twentieth century, giving way to a proliferation of beaded apparel.[4] Late in the twentieth century, large, plastic beads in a variety of colors entered the market, as seen here in the purple beaded waistband. The combination of different types, colors, and sizes of beads and metal bells makes this apron indicative of twentieth-century changes as well as age-old traditions of adorning the self.

African Apparel: Threaded Transformations across the 20th Century demonstrates through its fifty-four entries, comprising seventy-one individual objects, the strength and resilience of enduring practices that characterize African dress. It highlights the wide variety of cultural, religious, and political motivations for adornment, and the changing conceptions of self, reflected through dress practices of the last century and a half. Through long-standing global interactions, the embodiment of gendered realities, and the expression of generational conflicts and continuities, these textiles, headwear, and accessories highlight the artistry of African apparel.

FIG. 16 Beaded apron, Bhaca, South Africa (cat. 52)

Global Interactions

Entries 1–20

Note to the reader, entries are
identified by the contributor's initials:

MS Morgan Snoap '20
CT Cristina Toppin '21

Adire starch-resist cloth (detail),
Yoruba, Nigeria (cat. 7)

1
Silk wrap

Fès, Morocco
Silk with silk and metal embroidery
19th century
20 × 65 in.
Collection of William D. and
Norma Canelas Roth '65

Since antiquity people have desired the luxurious fabric of silk. Transporting the precious material along the famous Silk Road, caravans brought textiles from China to trade with Middle Easterners, Europeans, and Africans alike. Throughout history, various regional powers sought control over the silk route and, starting in the seventh century, Muslims dominated. Under Muslim control, silk production flourished and spread into regions of the Mediterranean, North Africa, and Europe—most notably to Spain, where Moors took up silkworm breeding and developed weaving technologies.[1] Following the 1492 fall of Granada, the last Moorish-controlled city in Spain, Moorish refugees flocked in droves to Morocco, largely settling in Fès, the cultural center of the country. With this influx of skilled artisans, Fès's silk industry thrived, employing the silk-spinning machines and brocade looms introduced by the new incomers.[2]

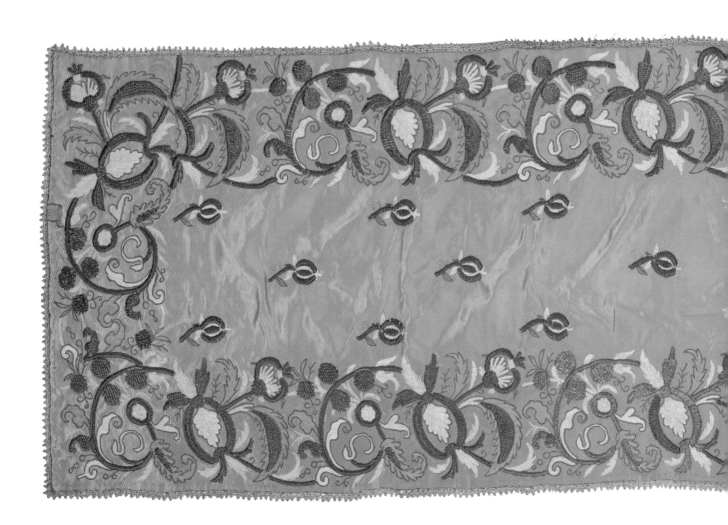

While splendid on their own, silk textiles were further embellished in Morocco with metal embroidery, as seen in this apricot silk wrap or belt. Flat metallic threads, often gold or silver, or metal threads wrapped around a silk thread core, ornament the glossy surface of the fabrics, tracing elegant floral designs. Historically, Jewish men living in Fès would have crafted these metallic threads, but nowadays they are often imported from Europe, particularly Italy.[3]

This specific textile features gold threads encircling a base of green silk embroidery. The embellishment forms an elaborate border of curling tendrils and blossoming buds that weave in and out of one another, seemingly bursting with life and movement. The gleaming gold embroidery winds across the supple silk, thereby lending further dimension and texture to this sumptuous textile. MS

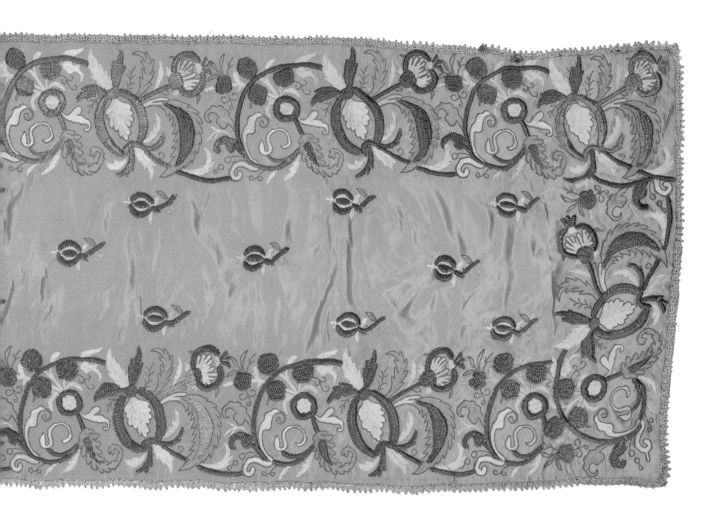

2
Silk belt *(hizam)*

Fès, Morocco
Silk
Late 19th century
7 × 154 in.
Collection of William D. and
Norma Canelas Roth '65

For many cultures, marriage represents an important transitionary step from childhood to adulthood. For Muslim women especially, marriage marks a full incorporation into social and religious life.[4] Because of the significance of this event, marriage ceremonies are elaborate affairs that call for equally elaborate clothing and adornment. One component of a Moroccan bride's extravagant attire is the hand-embroidered silk belt, or *hizam*, woven predominantly in Fès and other northern Moroccan cities. This long, two-toned belt is woven on a drawloom through a complex technique called *lampas*. Although the belt is worn by young women, it is notably fashioned by male weavers.[5]

Folded in half lengthwise or sometimes cut to be shared between family members, *hizams* are wound multiple times around a bride's midsection, on top of her caftan, to cinch in her waist, functioning like a corset.[6] In this way, the sash accentuates a bride's figure and

highlights her sexuality, yet also vouches for her modesty and chastity, as the belt is removed after the wedding ceremony to symbolize her virginity and readiness to consummate the marriage.[7]

The history of the *hizam* features a complex mix of Western and non-Western influences within Morocco. With the fall of Granada, many Spanish-Jewish artisans migrated to Morocco and settled in Fès. These Andalusian refugees brought their crafts and introduced to native Moroccans the weaving techniques and technologies used to create *hizam*.[8] As the production of these belts became an established part of Moroccan marriage customs, its embroidery patterns adapted to North African and Islamic aesthetics. Mixing with the Hispano-Moresque designs brought by the Andalusians, Islamic motifs, such as the eight-pointed star and *khamsa*, or Hand of Fatima, and European designs, like French brocades, combined to create a distinct design aesthetic.[9]

Given that these patterns are such a cultural and aesthetic amalgamation and have existed for centuries, it is difficult to date Moroccan silk belts. However, it is likely that the *hizam* seen here was woven in the late nineteenth century, as such belts fell out of style in Morocco at the turn of the twentieth century.[10] MS

Silk belt (detail), Fès, Morocco

3
Lapis lazuli necklace

West Africa
Lapis lazuli beads, cotton string
20th century
16 in.
Collection of William D. and
Norma Canelas Roth '65

4
Glass bottle necklace

West Africa
Glass bottle beads, cotton string
20th century
14 ¾ in.
Collection of William D. and
Norma Canelas Roth '65

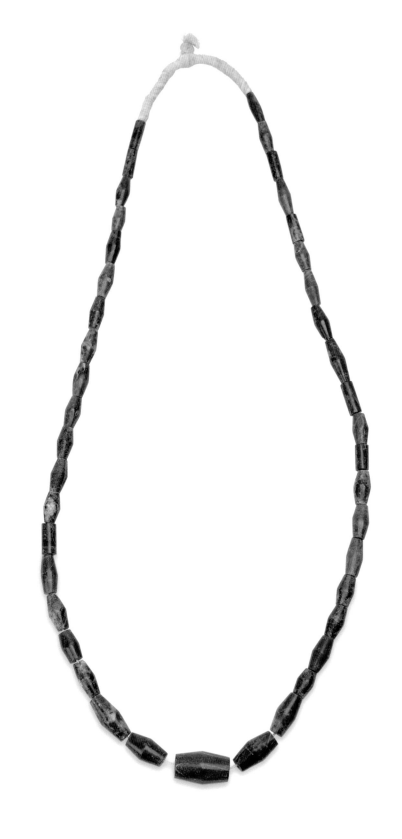

Since ancient times, lapis lazuli, a distinctly deep blue colored stone, has been coveted for luxury items across Asia, Europe, and Africa. Primarily mined in Badakhshan, a province of Afghanistan, lapis became an important trade good between Afghanistan and ancient Mesopotamia.[11] The stone was shipped to Mesopotamia in the form of blocks, which were then processed to separate pure lapis from its limestone cortex, and finally turned into beads for trade throughout the region.[12] Soon, lapis beads were introduced to Egypt via Mesopotamian traders, where they became important to Egyptian royal jewelry and were included in burials as symbols of wealth and status.[13]

Eventually, lapis lazuli became a stone traded and utilized in adornment across the African continent. Specifically, during the seventh century CE, Muslim Arabs established empires in North and West Africa, which facilitated the exchange of Middle Eastern goods (precious stones, glass beads, and amber) for West African resources (gold and ivory).[14] Such trade relations allowed for the creation of African lapis necklaces such as this one, which would have clearly proclaimed the wealth of its wearer. For those less fortunate, cheaper alternatives to the rare stone could be used while still achieving its bright blue coloration. Here, an African jeweler has crafted beads out of blue glass bottles and strung them to form a necklace mimicking the aesthetic of lapis. MS

5
Indigo strip-weave cloth

Ewe
Ghana
Cotton, indigo dye
20th century
127 × 86 in.
Collection of William D. and
Norma Canelas Roth '65

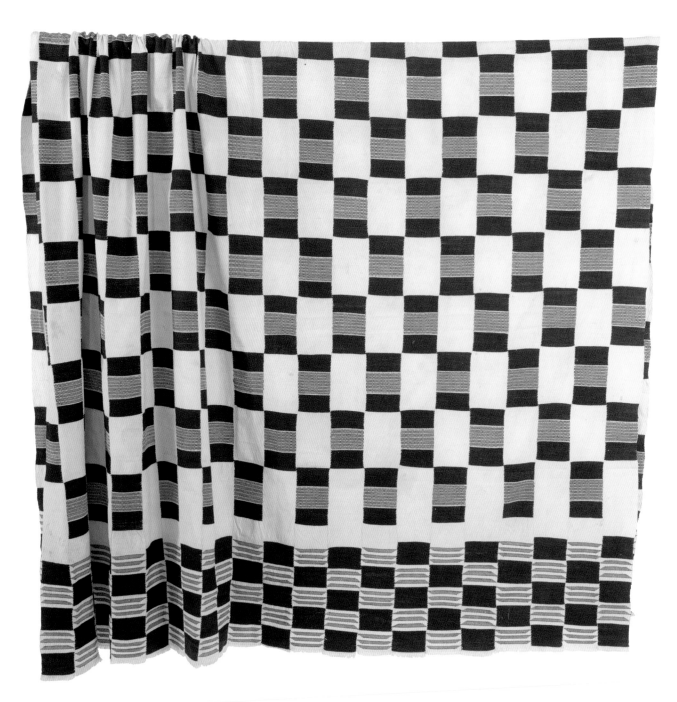

6
Strip-weave with
openwork cloth (*aso eleya*)

Yoruba
Nigeria
Cotton, with aqua and yellow weft thread
20th century
72 ¾ × 65 ½ in.
Collection of William D. and
Norma Canelas Roth '65

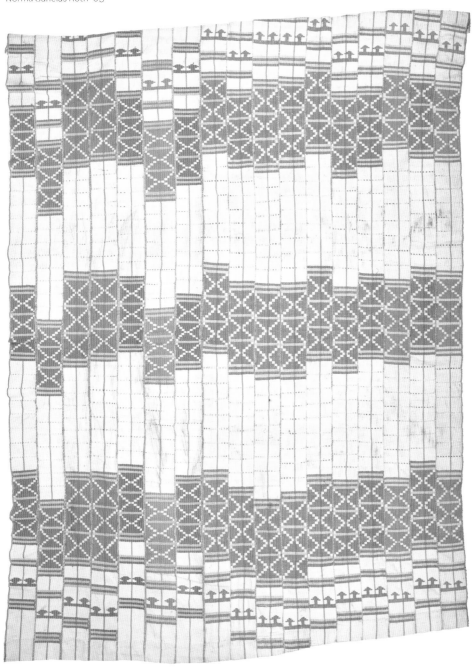

7
Adire starch-resist cloth

Yoruba
Nigeria
Cotton, indigo dye
Collected in 1976
70 × 71 ½ in.
Collection of William D. and
Norma Canelas Roth '65

The word *adire* means to tie and dye in the Yoruba language, and refers to the indigo-dyed cloth designs created using this technique. Often worn by women in southwestern Nigeria as wrappers, varying techniques exist to create *adire* designs. This cloth's bold, geometric, and floral designs organized in squares were made possible by *adire eleko*, or painted starch resist.

Women dyers first painted designs with cassava starch on handwoven cotton cloth before submerging the entire fabric in an indigo dye bath. They soon began using imported, factory-woven cloth after a late nineteenth-century British colonial directive taxed hand-woven fabric in order to promote the sale of British-manufactured textiles.[15] Dyers made good use of the even surface provided by the industrially woven cloth, which allowed for more intricate and precise painted starch-resist designs. A shortage of cloth following World War II allowed for the spread of inexpensive, printed cloth, including those that mimicked the designs of *adire* produced in Japan. In the 1960s, vibrant, synthetic dyes contributed to a "new *adire*," and candle wax joined cassava starch as an additional indigo-resist option.[16]

Dating from the late 1960s to early 1970s, this large example of *adire eleko* possesses two layers of designs. One set of designs is characterized by the varying shades of light blue to deep indigo garnered from the hand-painted cassava starch resist and subsequent submerging into the dye bath. The other design is imparted from the manufactured cloth's woven pattern, which appears as continuous, narrow bands of interlocking designs that run the length of the cloth. With its abstract animal and plant motifs, this cloth likely venerates the Yoruba sea goddess Olokun, who is believed to bring wealth and prosperity to her followers.[17] Beyond spiral, bird, floral, triangle, and striped motifs, one may spot Roman letters integrated into repeating designs, and even pairs of sunglasses. CT

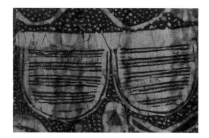

Adire starch-resist cloth (details), Yoruba, Nigeria

8
Fancy-print minidress

Owo, Nigeria
Cotton, synthetic dyes
1973
34 × 39 in.
Collection of James and MacKenzie Ryan,
former collection of Robin and Donna Poynor

Dating to before the fifteenth century, European textile trade with West Africa has developed into a complex economic and cultural interaction that shapes African identity and European industry alike. During the seventeenth century, European companies such as the Dutch West India Company began establishing strong trade relationships with West African textile markets, later solidifying these relations in the eighteenth and nineteenth centuries by accommodating changing textile tastes and demands within the region.[18] Throughout the twentieth-century colonial era and into the present day, the Dutch company Vlisco (established in 1846)[19] has dominated the contemporary market for wax print, an industrially woven and dyed fabric, thereby creating many of the popular designs seen today. Recently, however, Vlisco faces increased competition from Chinese manufacturers.[20]

Fancy-print minidress (details), Owo, Nigeria

European companies such as Vlisco introduced their manufactured imitations of Javanese wax-batik designs to a new market in West Africa in the late nineteenth century. Shockingly colorful and diverse in design, wax-print fabrics are produced through a technique originally used to make Javanese batik cloth, employing wax and dyes to create layered patterns. By applying wax to cloth and subsequently dyeing the fabric, designs take shape where the wax prevents the dye from fusing with the textile. One hallmark of wax prints that gained favor across West and Central Africa is craquelure, wherein lines of dye creep into patterns, resulting from the cracking of wax. Now an integral design aspect, it is mimicked in cheaper, printed alternatives made without the wax-resist method, called fancy-prints. Overall, wax- and fancy-print designs are vibrant and dynamic, ranging from abstract shapes to stylized flora and fauna to historic or political events in brightly contrasting colors.[21]

This fancy-print fabric was fashioned into a dress by a Nigerian tailor for Donna Poynor, wife of University of Florida Professor Emeritus of African Art History Robin Poynor, whom she accompanied on fieldwork in Owo, Nigeria. The designs reflect the Central Bank of Nigeria's transition from the British pound, shillings, and pence to the naira as the state's official currency in January 1973.[22] This bold print, featuring the currency's *kobo* coinage and naira notes, commemorates this significant event, which reflected the country's increasing independence in the postcolonial era. The silhouette of the minidress with bell sleeves also indicates its early 1970s moment. The fabric and its tailored style, together with its political undertones, act as a sort of cultural archive, telling the story of global interactions that culminated in this textile tradition and Donna Poynor's individual lived experience. MS

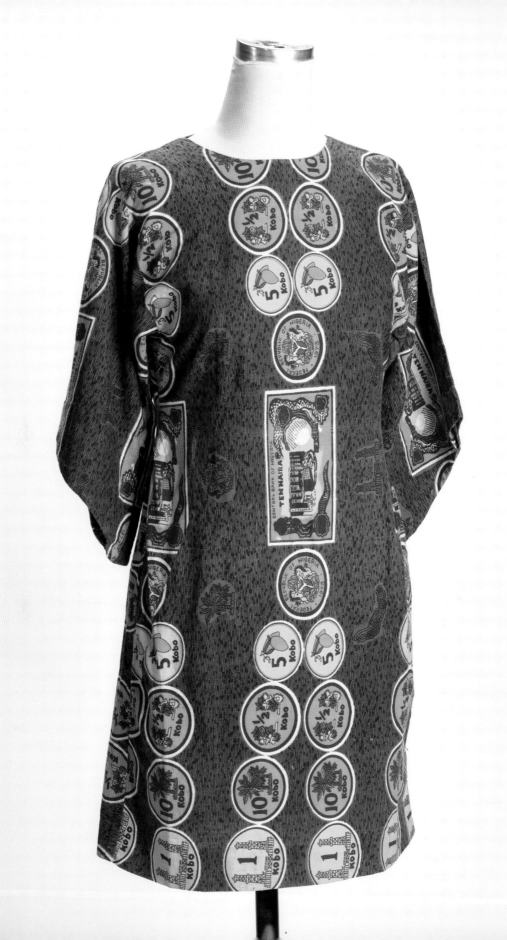

9
Beaded crown (*ade*)

Yoruba
Nigeria
Basketry form, wax-print cotton
cloth lining, glass beads
20th century
7 ½ × 7 ¼ × 7 ¼ in.
Collection of William D. and
Norma Canelas Roth '65

Renowned for their long-standing beadwork tradition, the Yoruba of southwest Nigeria have created beaded crowns (*ade*) for kings (*oba*) for centuries.[23] According to oral tradition, the earliest royal crown was crafted by the water goddess Olokun, who first made the headdress with cowrie shells.[24] Historically, the oba's crown was made out of cowries, until stone beads were incorporated around 1500. Through global trade, coral and glass beads were eventually added, joined by plastic beads in the contemporary era. For the Yoruba, beads represent unity, protection, and wealth; thus, their inclusion in royal regalia relates to the oba's importance and prestige.[25]

Traditionally, the *ade* was a tall, conical hat whose height lent it, and in turn the king, an imposing presence and power within Yoruba society. The crown also featured a long, beaded veil that covered the oba's face, thereby protecting the general public from his prevailing, penetrating gaze.[26] This custom changed in the 1890s when the British intervened in Yoruba civil conflict and colonial commands established firmer control within the region.[27] As Britain's colonial authority grew stronger, the Yoruba adapted their royal dress to reflect these shifting power dynamics.

Thus, the beaded *ade* began to take the form of a four-sided British crown, aligning the oba and his authority with that of the British monarchy. As a result of missionary efforts, these European-style crowns often include religious imagery, notably the Christian cross.[28] This example, however, retains the Yoruba iconography of birds, which represent the spiritual feminine power of older women that protects the king.[29] In this way, the beaded crown represents the interaction of cultures and the adaptation of royal headwear to changing circumstances during the colonial period. MS

Beaded crown (detail), Yoruba, Nigeria

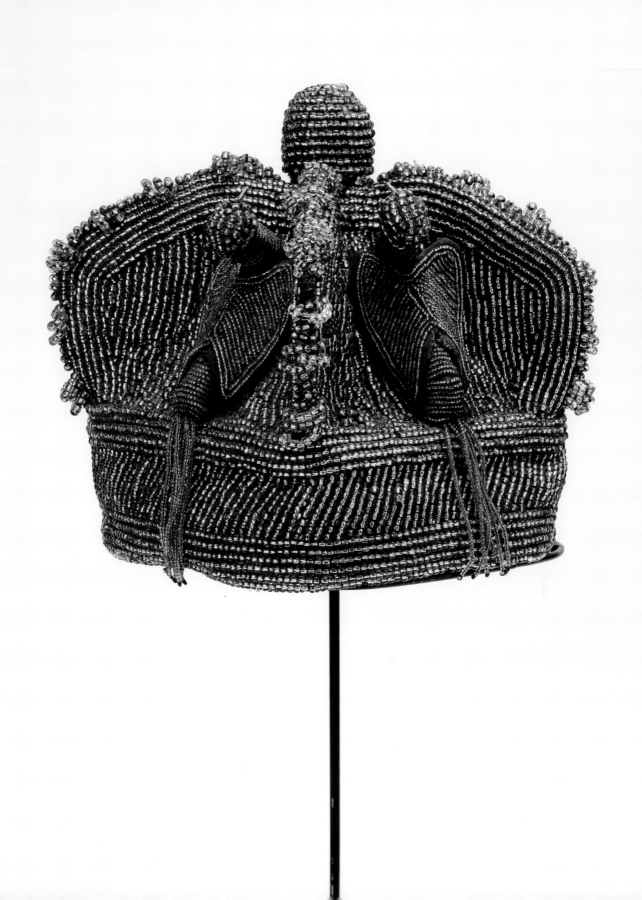

10
Pair of beaded bags

Yoruba
Nigeria
Glass beads, velvet bag,
wax-print cotton cloth lining
Early 20th century
Each bag 34 ½ × 8 ¼ in.
Collection of William D. and
Norma Canelas Roth '65

Although the prestigious art of bead-work is largely reserved for Yoruba royalty, other important individuals also have access to this chiefly medium. Like obas, diviners don elaborate beaded accessories, thereby underscoring their significance in Yoruba society. Diviners are endowed with spiritual powers through their relationship to *orun*, or the otherworld,[30] and are described by the Yoruba as "travelers who are strangers everywhere, at home nowhere" as they roam between different communities to study under other diviners.[31] Due to this nomadic lifestyle, diviners must constantly carry their equipment on their person: palm nuts; tray; tapper, which was hit against the tray to call Orunmila, the god of fate;[32] and an ivory effigy of the god Eshu. Thus, diviners adopted elaborately decorated bags to carry their spiritual tools, earning them the epithet *akapo*, or "carrier of bags."[33]

Bold in color and design, this near-identical pair of Yoruba diviner's bags is representative of the artistic tradition, with their precise geometric pattern-ing and repeating face motif. Triangles and diamonds, as seen in these bags, frequently appear in such beadwork to subdivide a surface and thereby energize it, according to the Yoruba.[34] Similarly, the five faces depicted here—a larger, central face and four smaller, stylized faces with wide gazes—punctuate the design plane and represent the four cardinal directions and the metaphorical crossroads between the spiritual and earthly realms, which is bridged by the diviner.[35] These carefully modeled faces are incorporated into the front panel of each bag. Their prominent features, notably their noses, mouths, and eyes, project out from the initial layer of beads to give greater depth and dimension to the figures.

Although this beadwork custom is quintessentially Yoruba, the materials involved in creating these diviner's bags come from a variety of global trade exchanges. For centuries, European trade has provided the small glass beads included in countless African artistic traditions. Additionally, the blue velvet composing the back panels is also likely from Europe. Finally, since wax print was not printed domestically until the 1960s independence era, the wax-print fabric incorporated into both bags' inner flaps further evidences global and regional trade relations. MS

Pair of beaded bags (details), Yoruba, Nigeria

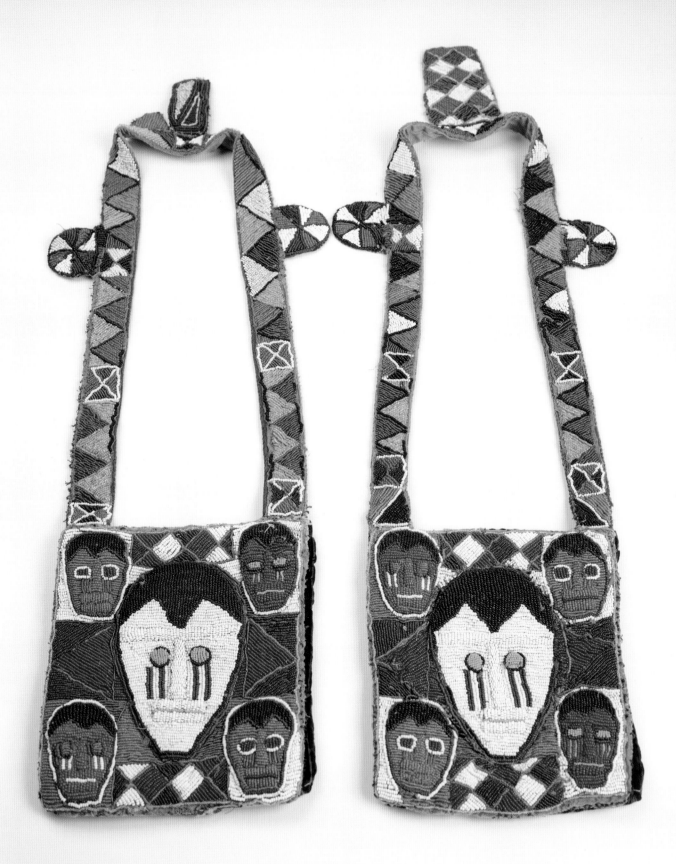

11
Resist-dyed indigo tunic

Bamileke
Cameroon
Cotton, indigo dye
20th century
29 ¼ × 28 ¼ in.
Collection of William D. and
Norma Canelas Roth '65

The prevalence of indigo throughout the continent, with its center in West Africa having spread to Central Africa, is evidenced through this resist-dyed tunic. *Ndop* cloth is common to the Bamileke, Bamum, and Kom kingdoms of the Cameroon Grassfields. The cloth is crafted from hand-spun cotton thread, which is handwoven on horizontal looms to create narrow strips of cloth. These strips are sewn together before tailoring or dyeing to create the base for *ndop*

designs. Such cloth bears a similarity in its use of indigo and a stitch-resist dye technique to *ukara* cloth, produced by the neighboring Igbo of southeastern Nigeria. As with *ukara* cloth, *ndop* cloth features designs made by temporary embroidery or raffia stitches.[36] These stitches resist the indigo dye and, once removed, create the light, contrasting motifs that carry messages of power.

The connection between *ndop* and *ukara* cloths reveals a history of

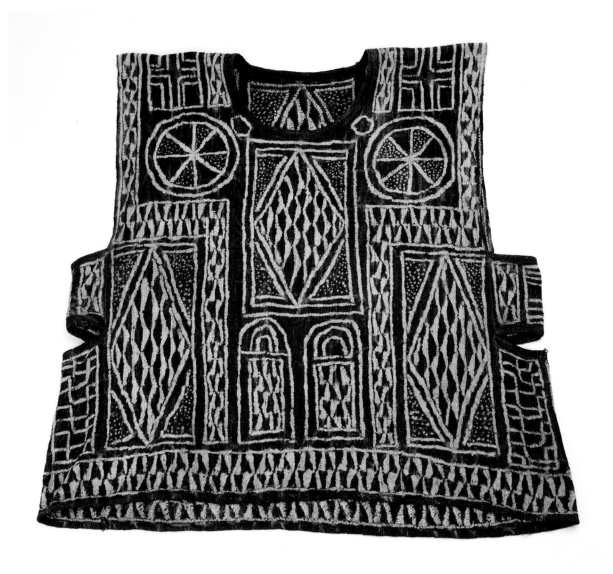

artistic exchange that emphasizes the significance of prestige cloth and royal regalia in the region. Indigo resist-dyed cloths were primarily exported from eastern Nigeria's Upper Benue River region as prized items to the Cameroon Grassfields before the early twentieth century, when Grassfields kingdoms began to produce them. The Bamum, for instance, began *ndop* production in the 1900s under the directive of the famed King Ibrahim Njoya. The exported cloths trace back to Hausa-speaking artisans residing in Wukari, Nigeria, helping to explain the positioning of indigo as a centerpiece in *ndop*, as the Hausa of northern Nigeria are renowned for their indigo strip-weave garments.[37]

Ndop cloths express the authority of ruling men in the Cameroon Grassfields, whether through display cloths, wrapped cloths, or in the form of a tailored tunic.[38] Both the front and back of this tunic's surface designs are composed of alternating indigo and resist-dyed triangles. The play between positive and negative space creates three large diamonds and their ensuing borders. Only the pie-shaped circles, with their speckled wedges, vary in number and positioning. The Bamileke wearer of this tunic clearly wished to exude his high status by wearing these *ndop* designs wherever he ventured. CT

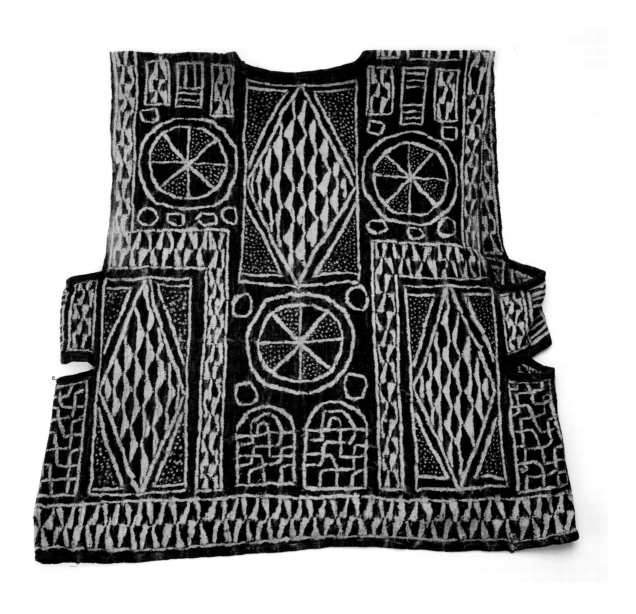

12
Embroidered tunic

Bamileke
Cameroon
Cotton with synthetic dyes
20th century
41 ¼ × 32 ½ in.
Collection of William D. and
Norma Canelas Roth '65

Situated in the western grasslands of Cameroon, the Bamileke and Bamum possess rich textile traditions that often exhibit an aesthetic of excess.[39] Whether traced with resist-dyed patterns, ornamented with embroidery, or scattered with beads, Cameroonian clothing overflows with elaborate, excessive design. Looking at the extravagant textiles, the eye bounces from one decoration to the next, constantly traversing the surface designs without settling on empty space. These tailored clothes exemplify the decorative aesthetic of the western grasslands.

Richly embroidered in vibrant red and gold, the Bamileke tunic would have been worn by a male notable.[40] This clothing style emerged at the beginning of the nineteenth century, made from imported European fabric and yarn and echoing the cut and elaborate embroidery of Hausa tunics from northern Nigeria.[41] In this way, the work represents a culmination of cultural exchange both within and outside of Africa. MS

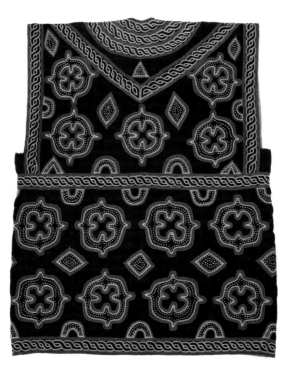

Embroidered tunic (verso), Bamileke, Cameroon

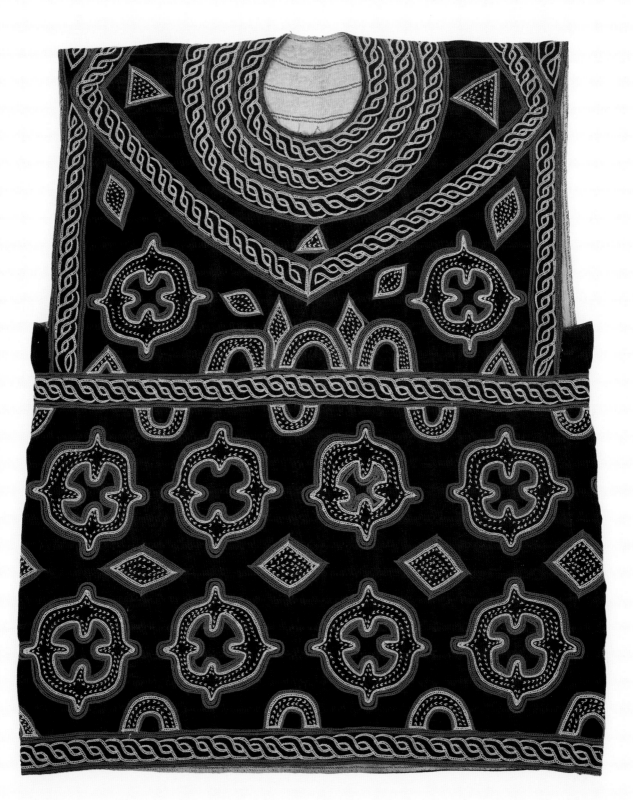

13
Beaded shirt

Bamileke
Cameroon
Raffia, cotton, indigo dye, glass beads
20th century
20 × 32 in.
Collection of William D. and
Norma Canelas Roth '65

For centuries, western Cameroon has
engaged in European trade, specifically
to obtain coveted glass beads. In the
sixteenth century, the Portuguese estab-
lished trading posts along the coast
to facilitate the exchange of goods.[42]
Historically, these beads were largely
reserved for royal and elite classes,
as their international origins and opulent
ornamentation enhanced the signif-
icance of the objects they adorned.
However, over time beadwork has
become more widespread.

 For example, this particular shirt,
composed of natural, indigo-dyed cloth,
trade beads, and woven raffia, is not an
elite article of clothing but rather one
worn in performance. Together with an
elaborately beaded elephant mask,
the shirt would be donned by a member
of a men's secret society for a dance
performance.[43] MS

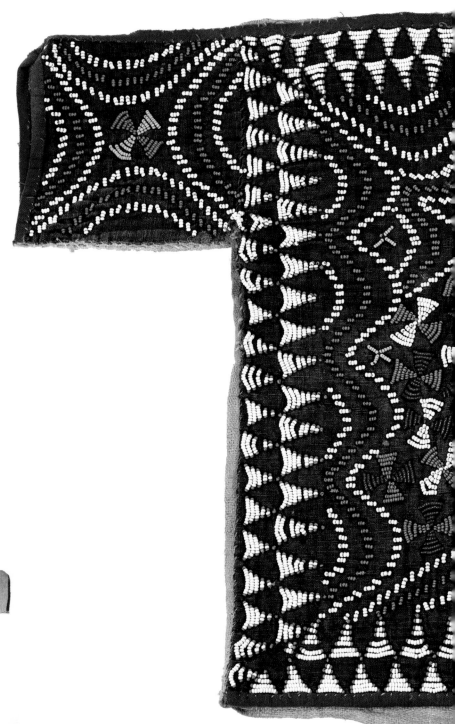

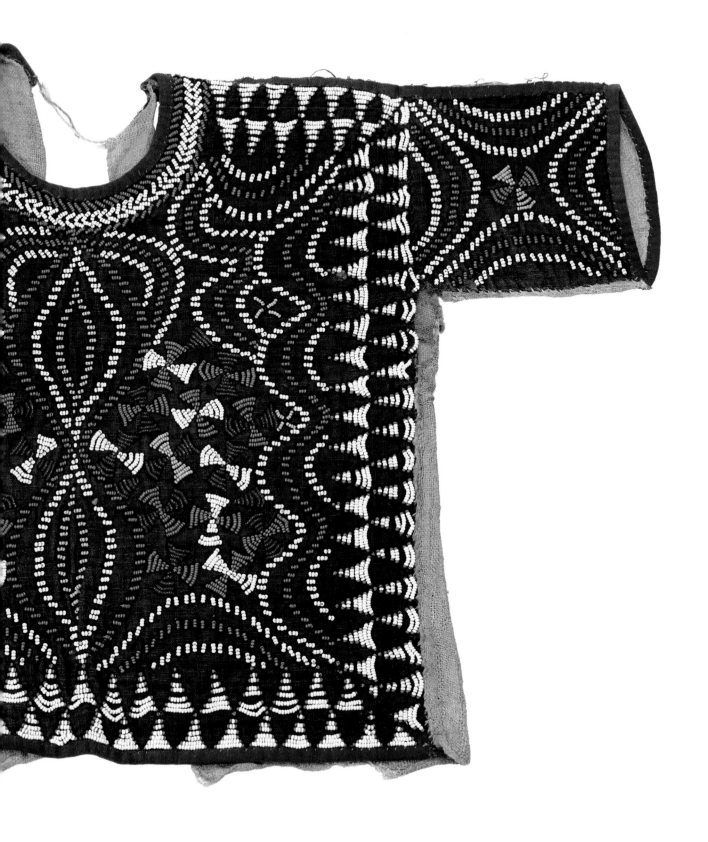

14 (OVERLEAF)

Kanga cloth with Obama

Purchased Nairobi, Kenya, 2009
Manufactured cotton cloth, synthetic dyes
21st century
41 ½ × 61 ½ in.
Collection of James and MacKenzie Ryan

Kanga cloth with guinea fowl

Purchased Dar es Salaam, Tanzania, 2011
Manufactured cotton cloth, synthetic dyes
21st century
41 ¼ × 117 in. (as shown 41 ¼ × 58 ½ in.)
Collection of James and MacKenzie Ryan

Kanga cloth with mosque

Purchased Dar es Salaam, Tanzania, 2010
Manufactured cotton cloth, synthetic dyes
21st century
40 × 124 in. (as shown 40 × 62 in.)
Samuel P. Harn Museum of Art;
Gift of James and MacKenzie Ryan,
2012.38.2

15

Kassamali Gulamhussein (K. G.) Peera, 1911/12–2011
Kanga design

Zanzibar
Japanese hand-painted design on paper,
cloth swatch, handwritten instructions
ca. 1960s
26 ½ × 32 ½ in.
Collection of James and MacKenzie Ryan

Defying traditional conceptions of what constitutes art, East Africa's *kanga* is an inexpensive, accessible, and commodified textile.[44] *Kanga* developed and immediately gained popularity in the late nineteenth century among women throughout the Swahili Coast, and women across East Africa eventually adopted the everyday cloth.[45] The textile serves as women's wrappers, baby carriers, wedding gifts, practical household wares, and as commemorative political items, such as this one honoring Barack Obama's 2008 election to the US presidency.[46]

Kanga consists of a pair of identical rectangular cloths, featuring a central panel of designs, Swahili idioms, and a complementing border. In this sense, the artistic agency behind *kanga* lies in its aesthetic, as the textile itself is factory-produced and -printed. Designers may illustrate flowers, fruits (including cashew nuts, often recognized outside of East Africa as paisley), animals, important structures (such as a mosque or, more likely, an Islamic shrine—as seen here), graphic patterns (especially stripes and spots), and household wares. These "blueprints" were sent to European manufacturers in the late nineteenth and early twentieth centuries, with Asian manufacturers later joining them. Finished *kanga* cloths were shipped back to ports along the Swahili Coast and distributed to textile wholesalers, who then sold smaller batches to market traders, who in turn sold cloths to customers.[47]

This entire process functioned as a network of global interactions during the colonial period. European and Asian manufacturers not only accepted *kanga* designs, but commissioned them as well, gauging consumer preferences. Indians residing in East Africa formed the bridge between *kanga* producers and consumers, fueling this business venture by serving as sellers, designers, and company envoys. This illustration of yellow and green flowers, hand-painted in Japan, complete with manufacturer instructions (see the *y*'s written to represent "yellow"), is the work of one such Indian local, Kassamali Gulamhussein (K. G.) Peera.[48]

East African women have proven to be a discerning clientele, if of modest means. While women will typically own several dozen pairs of *kanga* cloths, they carefully select each one for its flattering motifs and appropriate Swahili phrases that can convey silent messages to spouses, in-laws, rivals, and friends. It is ironic, then, that the name *kanga* in Swahili translates to guinea fowl, a domesticated bird known for its flashy, spotted plumage, its tendency to travel in groups, and its incessant chattering. Oral tradition suggests that the first women who adopted this graphically printed cloth were characterized as such by their male detractors, and the name remains. CT

Kassamali Gulamhussein Peera, *Kanga* design (detail), Zanzibar

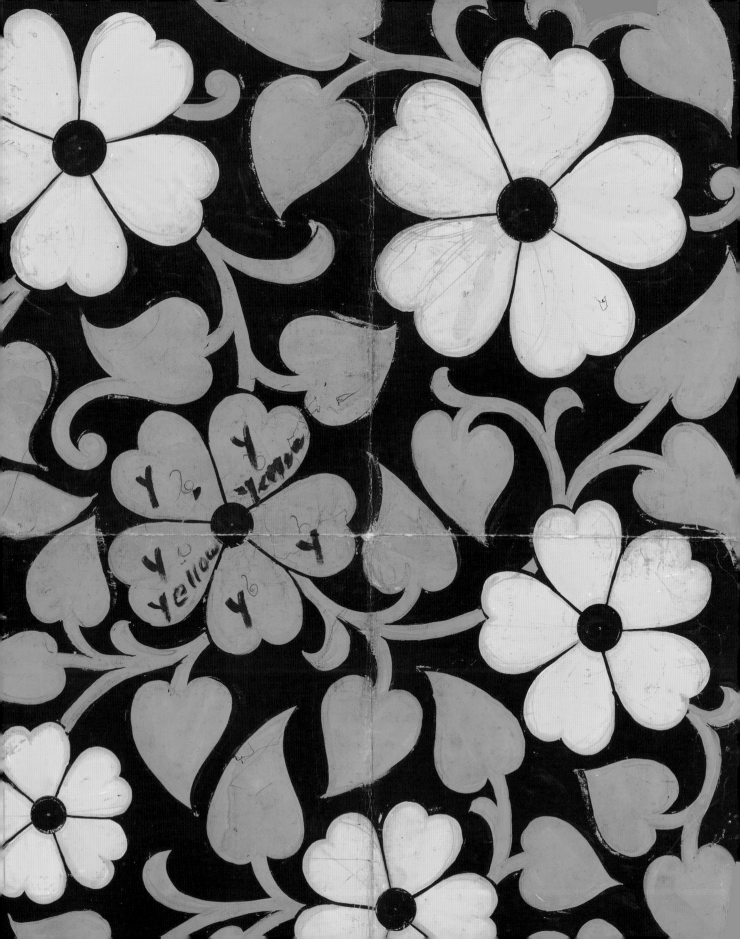

Hongera Barack Obama /
Congratulations,
Barack Obama

*Upendo na amani
ametujalia mungu /*
Love and peace have
been granted by God

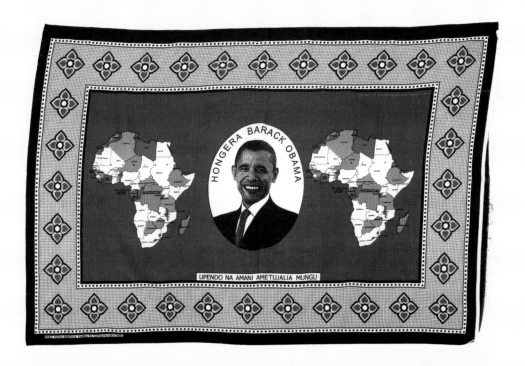

*Pokea zawadi mama
japo hailingani na
malezi /* Mothers receive
gifts that do not
match their training

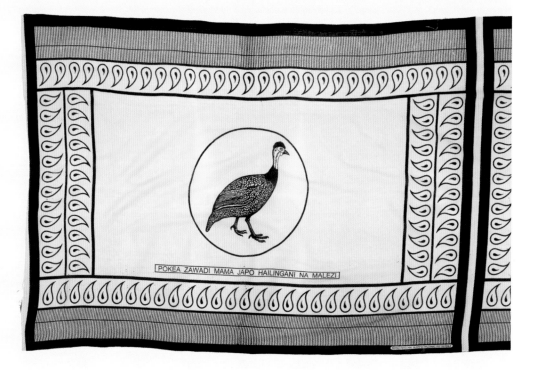

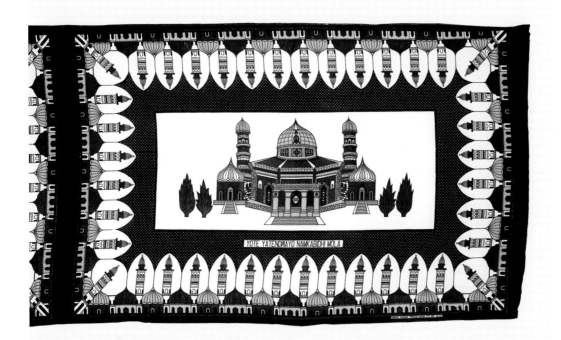

*Yote yatendwayo
namkabidhi mola /*
All that happens to me
is entrusted to God

K.G. Peera wrote the
instructions in his first
language, Gujarati,
spoken in the western
Indian state of Gujarat,
from whence his
family emigrated.

16
Royal *yet* belt

Kuba
Democratic Republic of the Congo
Leather, raffia, glass beads, cowrie shells,
conch shell
20th century
8 ½ × 50 ½ in.
Collection of William D. and
Norma Canelas Roth '65

Bursting with extravagant ornamentation, the Kuba *yet* belt could only be fit for a king. Its considerable mass, weighed down by hundreds of cowrie shells and glass beads, hangs heavy on the waist of the Kuba king, or *bwami*, signifying his authority and importance.[49] As in the case of many prestige objects, the larger and more lavish the item, the more significant the individual. This particular belt consists of nearly two dozen pendants representing important objects and motifs in Kuba society. For example, the *imbol*, or endless knot, appears on a few pendants and echoes the patterns of Kuba textiles (see cats. 46, 47).[50] A strong sense of geometry and design is embedded within this object and, like Kuba textiles, attests to the artistic innovation and ornate aesthetic of this Central African culture.

The striking visual impact of the belt owes itself to a complex system of global exchanges that provided its components. Cowrie shells, abundant in textiles and adornment across Africa, originate in the Indian Ocean, while glass seed beads, integral to African beadwork, are procured from Europe. Active in intercontinental trade networks, the Kuba have employed foreign resources to develop a distinctly local artistic tradition. In addition to the cowries and beads, this specific belt features a large cylindrical shell, impossible to find in Central Africa. The shell likely traveled from the coast inland to the Democratic Republic of the Congo by interregional trade. Thus, this singular object results from countless communications and connections both within and outside of the African continent. MS

Royal *yet* belt (detail), Kuba, Democratic
Republic of the Congo

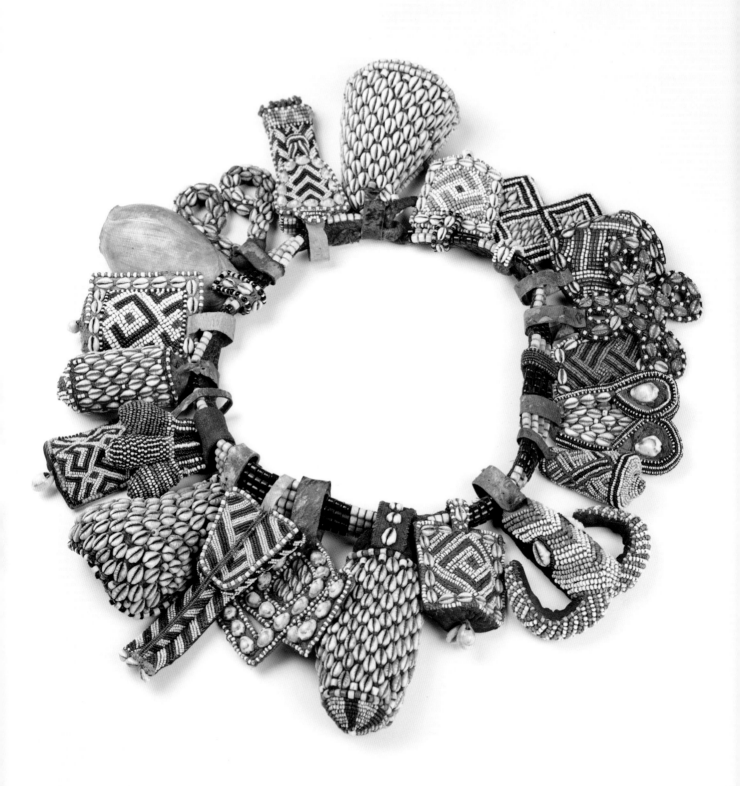

17
Silver cross pendants

Upper and far right: Gojam crosses
Center and lower right: Lalibela crosses
Bottom left: Gojam cross of post-Axumite era
Left: variation on Gojam cross
Upper left: filigree cross
Ethiopia
Silver
20th century
Various sizes; smallest 2 × 1 in.
to largest 5 ¼ × 4 ½ in.
Collection of William D. and
Norma Canelas Roth '65

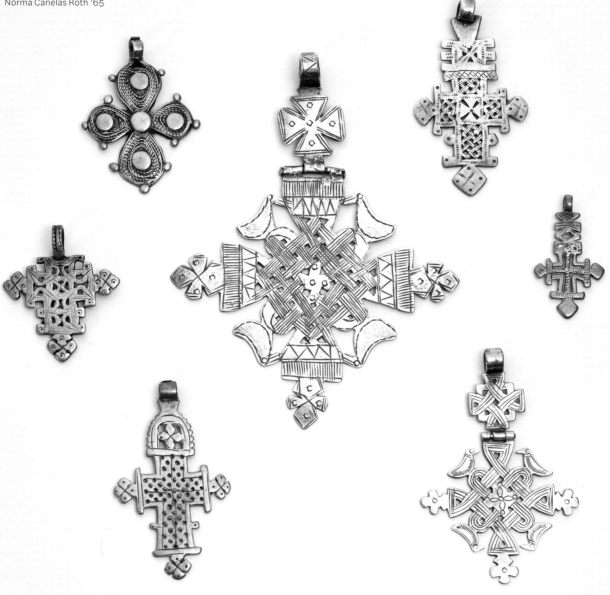

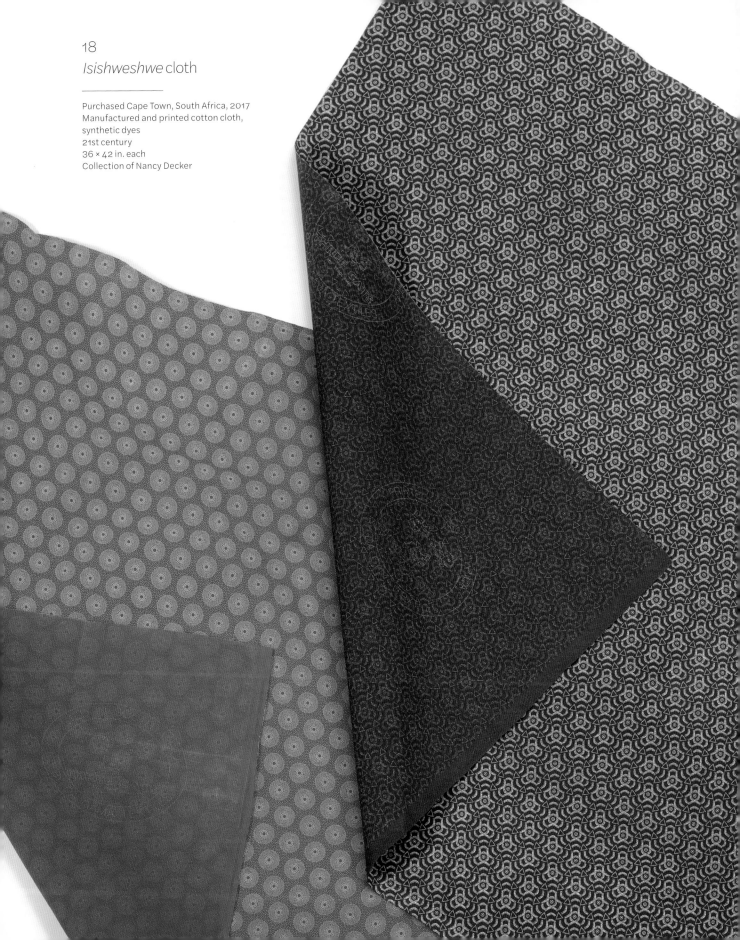

18

Isishweshwe cloth

Purchased Cape Town, South Africa, 2017
Manufactured and printed cotton cloth,
synthetic dyes
21st century
36 × 42 in. each
Collection of Nancy Decker

19
Beaded collar

———————————

Zulu
South Africa
Glass beads, cotton thread
Mid- to late 20th century
12 × 21 in.
Collection of William D. and
Norma Canelas Roth '65

20
Beaded collar

———————————

Xhosa or Mfengu
South Africa
Glass beads, cotton thread, button
Mid- to late 20th century
8 × 11 ½ in.
Collection of William D. and
Norma Canelas Roth '65

Today, South African art is best known for its elaborate beadwork—belts, aprons, necklaces, and collars, all intricately crafted in vibrantly colored glass beads. However, prior to European trade, South African clothing and adornment consisted mostly of animal skins decorated with ostrich shell beads.[51] Introduced by the Portuguese, glass beads originating from Venice, Bohemia, Holland, and India quickly assimilated into South African society and swiftly established a new artistic style.[52] Despite being a foreign good, South Africans embraced European glass beads and they soon dominated indigenous dress and even the economy. Beads were not only utilized in clothing production, but were also traded among South Africans as important forms of currency. In fact, at one point during the nineteenth century, South Africa was the largest consumer of beads in the world.[53]

Created by women, beaded pieces are worn by men and women alike, both day-to-day and for ceremonial or special occassions.[54] These beaded collars provide examples of the distinct aesthetics of two South African groups, the Zulu and Xhosa. Primarily white with accents of green, red, and blue, the first collar displays a markedly Zulu aesthetic. Pure colors and bold geometric designs characterize Zulu beaded art, which stands apart from the softer colors and modest design of the Xhosa collar.[55] The pink and blue hues of this particular Xhosa piece could signify that it was made by the Mfengu, a Xhosa-speaking group who fled the Zulu Kingdom in the early 1800s.[56] Both collars exhibit expert craftsmanship and unique design perspectives that attest to the artistic diversity within one region. MS

Beaded collar (detail), Zulu, South Africa

Beaded collar (detail), Xhosa or Mfengu, South Africa

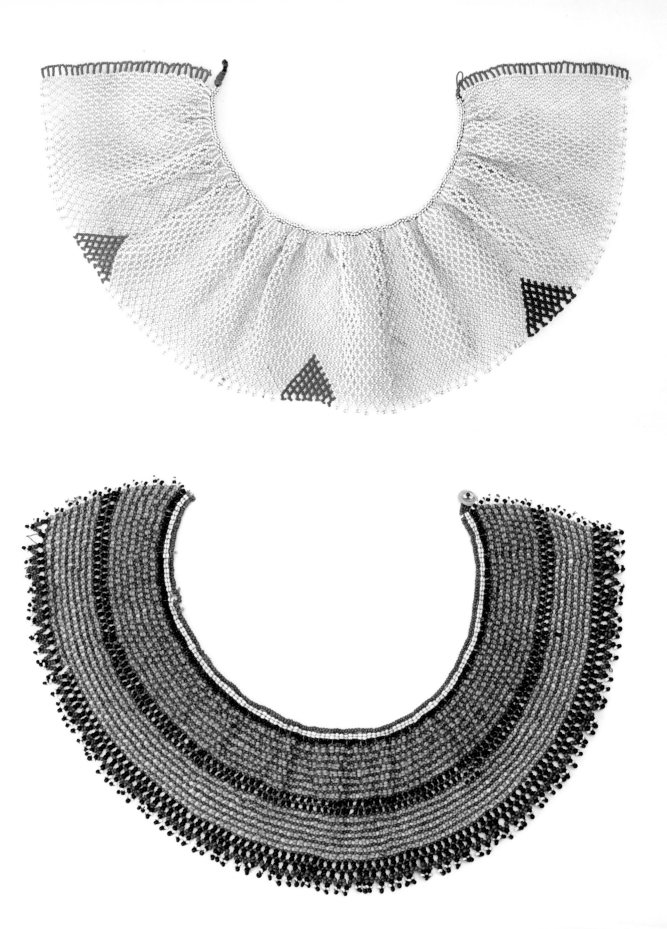

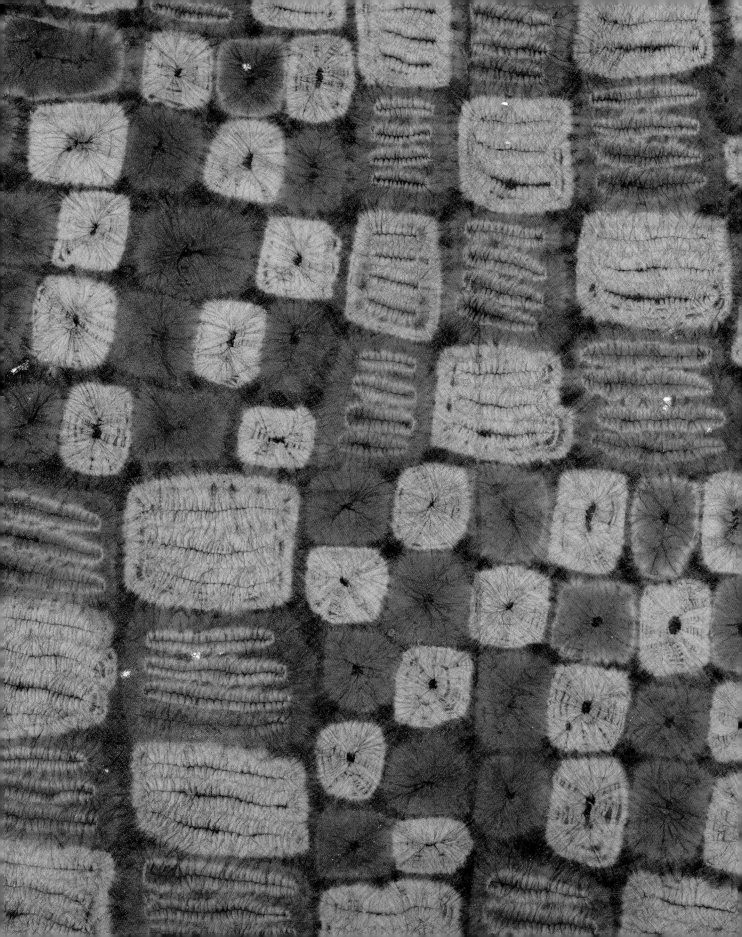

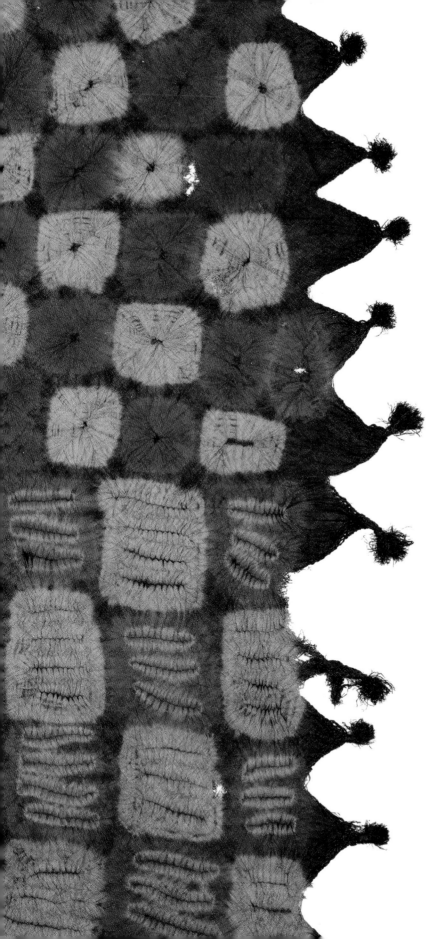

Gender

————————

Entries 21–36

Raffia tie-dyed cloth (detail), Dida,
Côte d'Ivoire (cat. 27)

21
Marriage waistcoat (farmla)

Raf-Raf, Tunisia
Silk with silk embroidery
19th century
28 ¼ × 21 ½ in.
Collection of William D. and
Norma Canelas Roth '65

Prior to European colonial intervention during the eighteenth and nineteenth centuries, North Africa was largely controlled by the Ottomans. Under foreign power, the countries of the Maghreb—with the exception of Morocco, which resisted direct Ottoman control—engaged in cultural exchange with the Turks, creating many of the North African textile aesthetics that persist to this day.[1] Embroidery styles in particular adopted elements and motifs from Turkish artistic traditions to the point that it is often difficult to differentiate between embroidered textiles from the various regions of North Africa.[2] This example, a Tunisian woman's marriage waistcoat, or farmla,[3] refers directly back to this time of Turkish control in its crescent moon and star motif, which symbolized the Ottoman Empire. Stitched in silk thread, the upturned forms of the crescents on either side of the garment curve elegantly around the stars and form the openings of two small pockets. Today, the same motif is echoed in the flag of Tunisia as well as other countries previously under Ottoman rule.

This pink silk farmla likely originates from the northeastern Tunisian fishing village of Raf-Raf. Known for its embroidered bridal costumes, Raf-Raf is a small coastal town where women have historically crafted such garments. The female embroiderers drew inspiration from the designs painted onto the bride's hands for her marriage ceremony, and generations of women passed down such patterns for continuous use.[4] This waistcoat features organic, floral motifs in soft shades of lavender and chartreuse. Bold, red piping lines the central and lower hems, delicate baubles decorate the neckline, and vibrant pink ribbon trims the farmla's characteristic winged sleeves. Together, these subtle details create a harmonious balance of color and design. Although much work and care were put into crafting this waistcoat, it would ultimately be worn beneath the marriage tunic, or susana.[5] Thus, the artistic designs are purely for the pleasure of the bride on her wedding day.[6] MS

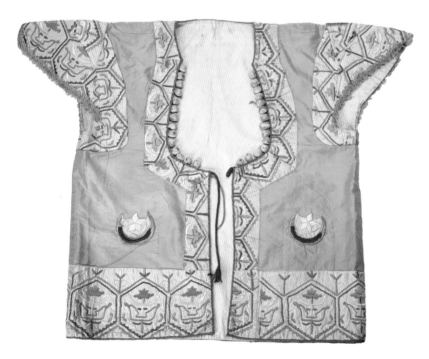

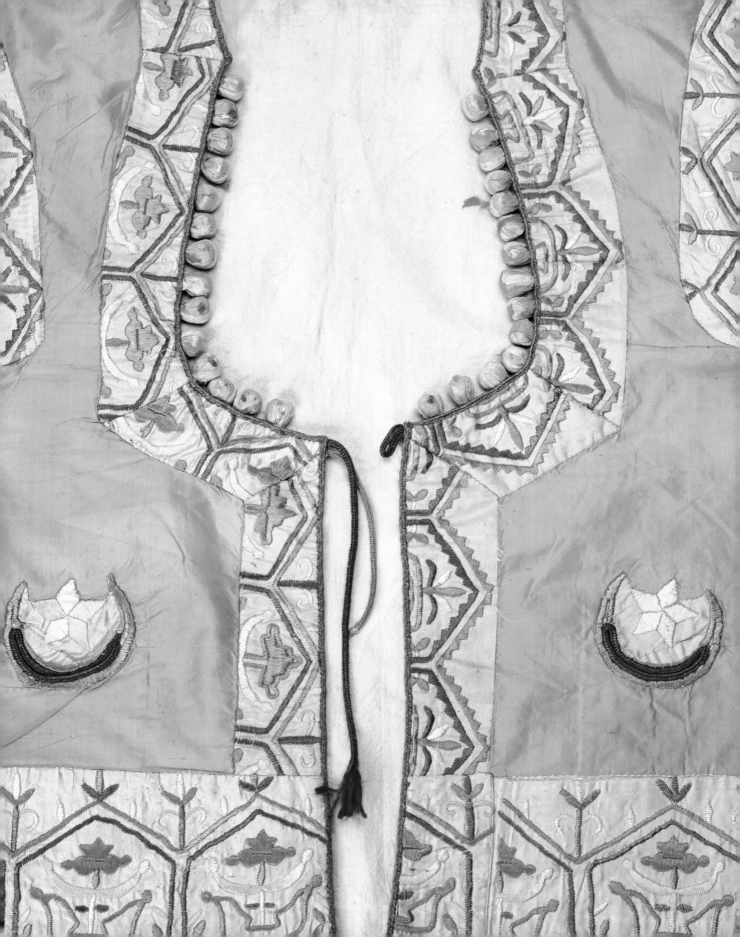

Silver pectoral fibulae

Imazighen
Morocco
Silver, enamel, silver coins
Early 20th century
12 × 6 ¾ in.
Collection of William D. and
Norma Canelas Roth '65

Although most of the Western world knows them as Berbers, the indigenous people of northwestern Africa refer to themselves as the Imazighen (adj. Amazigh).[7] Unlike the majority of North Africans, the Imazighen are not of Arabic origin. However, their artistic traditions, specifically their metal jewelry pieces, express Arab, Spanish, and Jewish aesthetics as a result of historic Arab conquest and Jewish migration from Spain to northwestern Africa.[8] This set of silver Amazigh fibulae, like brooches, fastens a woman's garment at both shoulders. Here, the Jewish Star of David is seen on one side of a silver coin, while its reverse displays Arabic text surrounding the date 1336 from the Islamic Hijri calendar (approximately 1917 in the Western Gregorian calendar).

Silver coins are commonly found in Amazigh jewelry. They are employed both as ornamentation and as the source of metal; silver coins were historically melted down to provide the precious metal to create the jewelry itself.[9] The dangling coins jingle musically as the fibulae's wearer moves, lending an aural component to the visually bold jewelry. In addition to this precious metal, jewelers incorporate semiprecious stones into their works, such as carnelian (orange or red in color) and amazonite (green) stones inlaid into the silver.[10] As a less expensive alternative, jewelers may choose to use colorful enameling, as seen in this work.

Elaborate silver jewelry, like this set of fibulae, strongly defines Amazigh female identity.[11] Gifted to brides by their parents, though financed by future in-laws, women proudly wear such jewelry on special occasions throughout their lives. This feminine connection to jewelry is also reflected in common motifs, such as the inverted triangle shape of the fibulae that represents women in Amazigh art. The central, egg-shaped pendant doubles as a container for holding perfumed herbs, which lends the wearer a desirable aroma.[12] Thus, while an Amazigh woman often wears plain clothing, her bold jewelry provides ornamentation to her ensemble and facilitates the outward expression of her gender and Amazigh identity.[13] MS

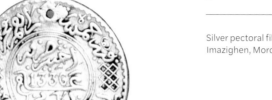

Silver pectoral fibulae (details),
Imazighen, Morocco

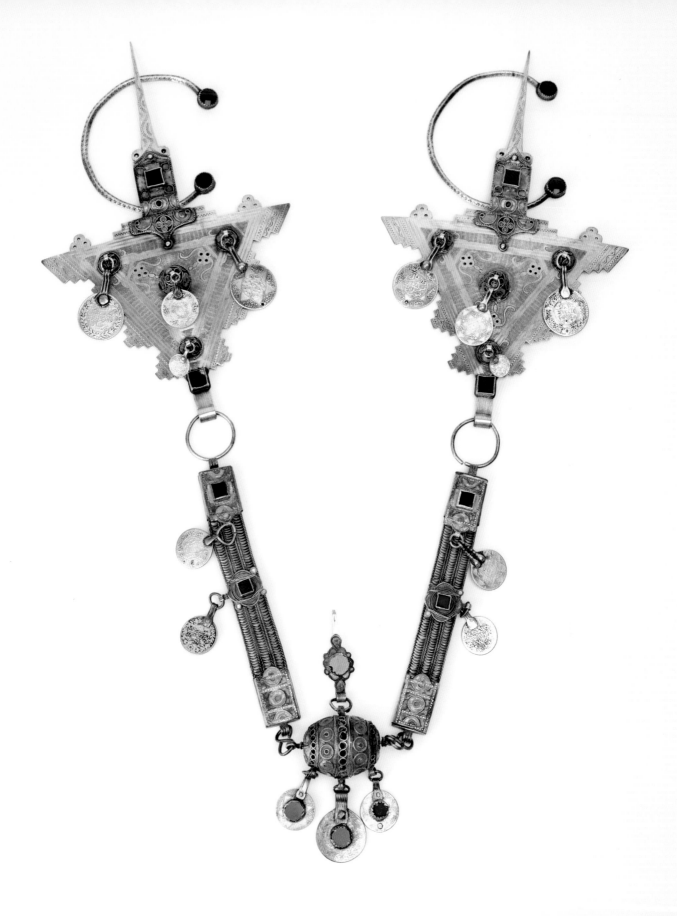

23
Wool shawl

Imazighen
Algeria
Naturally dyed wool with undyed cotton warp
and geometric designs
Early 20th century
22 ½ × 81 in.
Collection of William D. and
Norma Canelas Roth '65

As in Morocco and Tunisia, the non-Arab Imazighen in Algeria maintained a long and rich history of textile production. Unfortunately, whereas this tradition of handweaving has persisted in the other two countries, it has largely fallen out of custom in Algeria since its revolution against French colonial powers and declaration of independence in 1962.[14] In the centuries preceding the Algerian War of Independence, however, Amazigh women wove textiles with bold and intricate designs, demonstrating their great skill in these complex techniques.

Algerian weaving techniques were similar to those utilized by Amazigh weavers in Morocco and Tunisia: the use of hand-spun wool and cotton woven tapestry-style on upright looms.[15] In contrast to the Moroccan and Tunisian Imazighen, the Algerians employed unique dyeing techniques. Women dyers first soaked wool in a priming substance to facilitate the adherence of pigment to fibers, then dyed the wool in a mixture of henna leaves and pomegranate rinds, which created the rich shades of brown and apricot seen in this shawl. The undyed cotton warp threads are apparent in the fringed edges and provide the geometric patterns throughout.

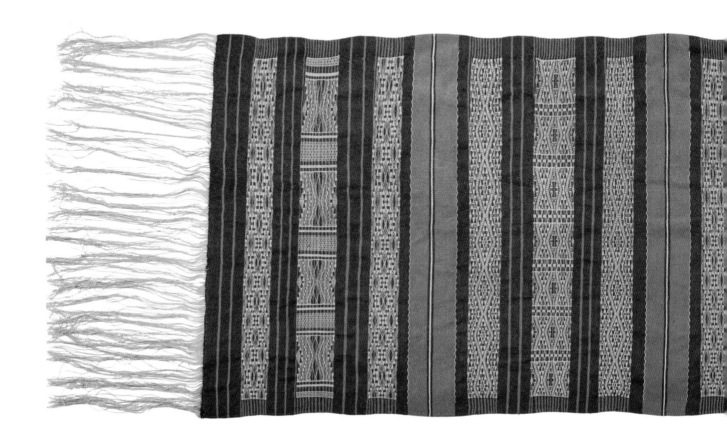

Amazigh women weavers liken the process of weaving to symbolically "giving birth" to these textiles, which strongly underscores the idea of clothing as a living art form. Before beginning to weave, a woman physically straddles her loom, raises her skirts, and walks over the warp to confront the yet-unborn weave with her sex in preparation for its eventual "birth."[16] She then labors lovingly over the loom, carefully crafting the weave, thereby granting it a soul and bringing it into this world as she would a child.[17] In this way, textile weaving reinforces the role of women as life-givers in Amazigh society and highlights their creative powers, both in a reproductive and artistic sense.[18] MS

Wool shawl (detail), Imazighen, Algeria

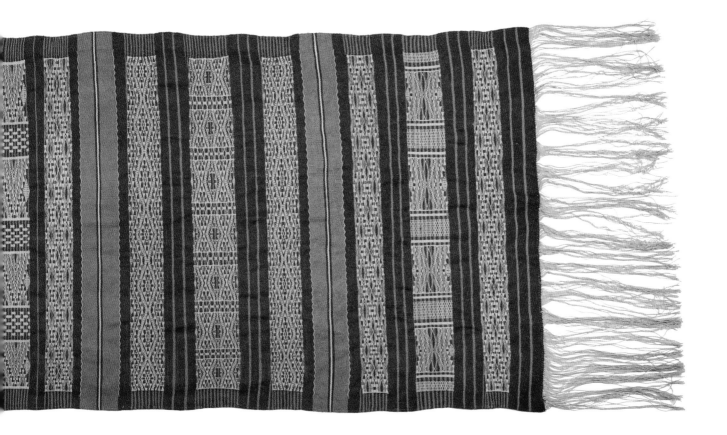

24
Bogolanfini wrapper

Bamana
Mali
Cotton and mud dye
20th century
39 × 59 in.
Collection of William D. and
Norma Canelas Roth '65

Bogolanfini, or "cloth of mud," refers to the protective cloth, the abstracted designs, and the dyeing process that utilizes a fermented mud-based pigment. The creation and use of such textiles are highly gendered among Bamana communities of Mali. Women spin undyed cotton into threads, and men weave these threads into cloth strips using horizontal looms. The undyed cotton strips are then sewn into cloth, providing women dyers the blank canvas on which to create surface designs. Prior to dyeing, women treat the woven cloth with an herb-leaf priming mixture, leaving the cloth to dry in the sunlight. Women laboriously paint the dark background with fermented mud, leaving the desired lighter motifs to contrast. They apply a soapy substance to the undyed sections to increase the color contrast after another round of sun-drying. Women may repeat this labor-intensive process multiple times until the desired depth of color is achieved.[19]

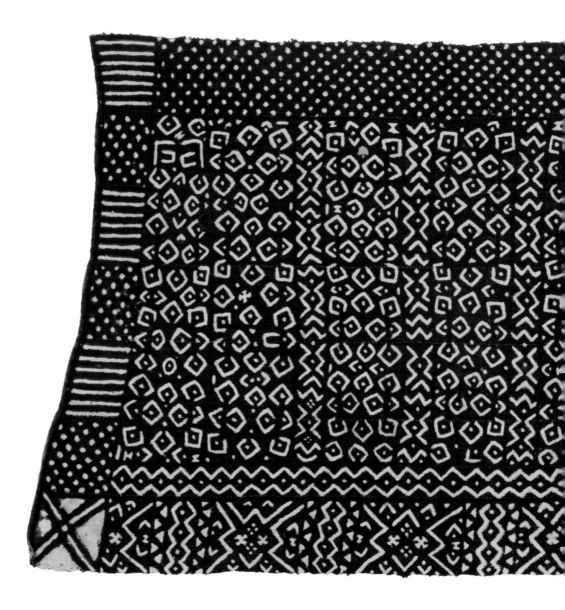

The patterns on *bogolanfini* cloths are often abstract shapes composed of lines and dots. The patterns' layers of meaning might be revealed to women as they age and gain greater insight into Bamana gendered knowledge, which has been passed down for generations and predates the dominance of Islam in Mali today. *Bogolanfini* cloths are divided into five sections, with separate borders and a central panel. The repeating motif of this cloth's central panel is composed mainly of squared-off open forms encircling a dot; known as the "fertile cow" motif, on one level it likens the ideal fertility of women to cows, which birth many calves and produce a great deal of milk to nurture their young.[20]

As protective cloths, *bogolanfini* are employed by women as wrappers following significant and vulnerable moments in their lives. Adolescent rites, often including excision; marriage, marking a woman's first sexual experience; and childbirth are all precarious moments necessitating the protection *bogonlanfini* offers. Bamana male hunters also wear *bogolanfini* shirts to guard them from dangerous forces while tracking animals, as they leave the safety of the village and live alone in the wilderness for many days.[21] A highly gendered cloth in its production and use, *bogolanfini* are among the most widely recognized African textiles for their bold design aesthetic and unique dyeing process. CT

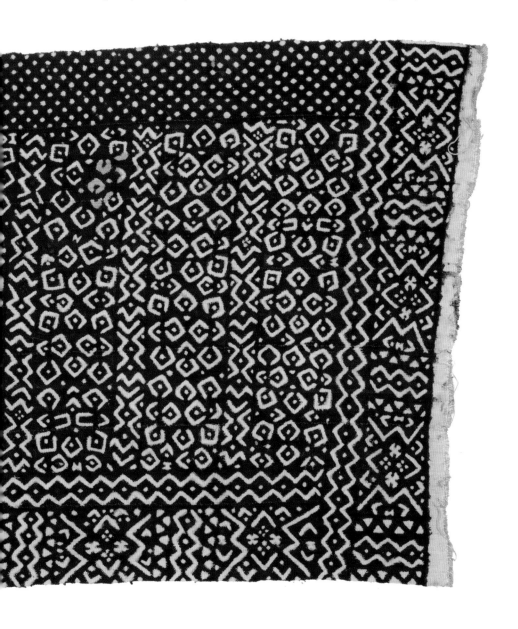

25 (OPPOSITE LEFT)
Crocheted hat *(ashetu)*

Bamileke
Cameroon
Cotton with indigo and red dyes
Early 20th century
5 ½ × 9 ½ × 9 ½ in.
Collection of William D. and
Norma Canelas Roth '65

26 (OPPOSITE RIGHT)
Crocheted prestige hat *(ashetu)*

Bamileke
Cameroon
Cotton with indigo dye
Early 20th century
8 ½ × 7 × 6 in.
Collection of William D. and
Norma Canelas Roth '65

In the Cameroonian Grassfields, a hat says a great deal about a person. Functioning as an important platform to tout one's ethnicity, status, and title, headgear creates a visual language that all members of society recognize and acknowledge. All men, with the exception of slaves, were historically required to cover their heads day-to-day and to change their headgear according to the occasion.[22] Elaborate, feathered hats in vibrant vermilion and rich chestnut appear at ritual events and royal ceremonies, but the less ornate, crocheted cotton caps, or *ashetu*, constituted daily dress.[23]

These everyday hats present bold, geometric designs by employing a variety of crochet stitches to form contrasting patterns and shapes. Many of the caps feature only blue and white blocks of color, sometimes utilizing red as a strong accent in the form of a "bull's-eye" on the very top, akin to the cylindrical example on the left here.[24] However, this *ashetu* employs red in an additional way: a thin scarlet border trims the edge of the crowning ruffle, providing a striking contrast with the rhythmic blue and white zigzags encircling the hat.

While the ruffled *ashetu* is an example of a common cap, the bulbous blue and white *ashetu* represents a more prestigious version. In its craftsmanship, this headwear exhibits the complex techniques of openwork, appearing lacelike down the hat's center, as well as sculptural constructions in the three-dimensional, star-shaped designs on either side. Crocheted caps like this one with short or long protruding burls are said to recall past and present fashionable men's hairstyles.[25] Caps with longer crocheted appendages especially resemble popular braided or dreadlocked coiffures. MS

Crocheted hat and crocheted prestige hat (details), Bamileke, Cameroon

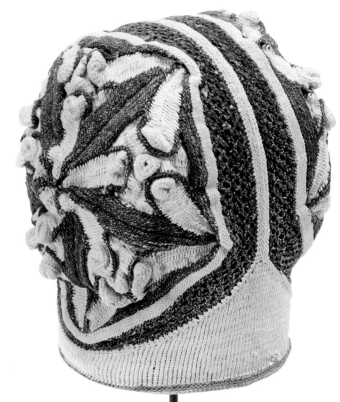

Raffia tie-dyed cloth

Dida
Côte d'Ivoire
Raffia, natural dyes
20th century
41 × 48 in.
Collection of William D. and
Norma Canelas Roth '65

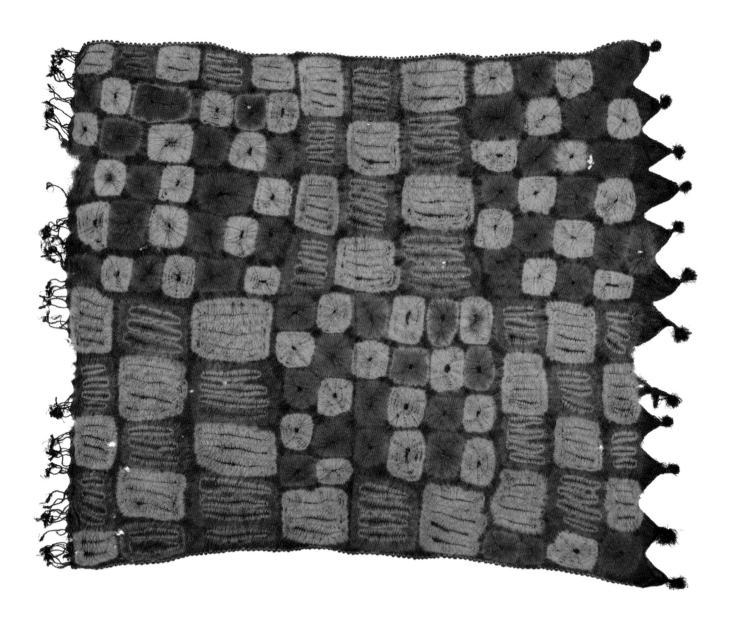

28
Ivory ring and bangles

Dinka
South Sudan
Ivory, raffia thread
Early 20th century
Ring: 2 × 1 × ½ in.
Thick bangle: 5 × 5 × 1 ¾ in.
Thin bangle: 5 ¾ × 5 ¼ × ⅛ in.
Collection of William D. and
Norma Canelas Roth '65

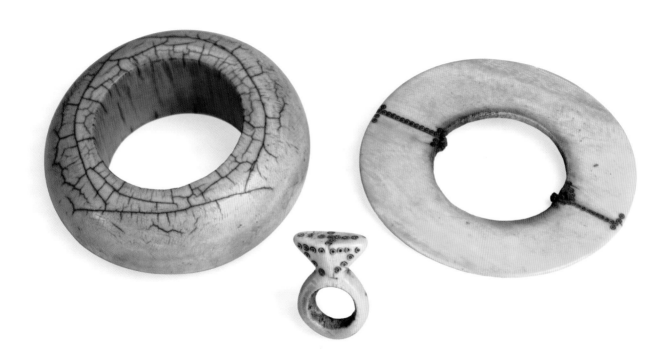

29
Beaded corset (*malual*)

Dinka
South Sudan
Glass beads, cotton thread, twine, iron
20th century
26 ½ × 15 × 6 ½ in.
Collection of William D. and
Norma Canelas Roth '65

While corsetry in the West has long been associated with women, young Dinka men in South Sudan donned beaded corsets, called *malual*, in the second half of the twentieth century.[26] Adolescent men adopted such corsets at puberty for their daily wear, wearing no other garments to cover their bodies.[27] Their seminomadic, pastoral lifestyle made the beaded corset a convenient art form as it traveled with its wearer.

Made almost entirely of threaded glass beads, *malual* likely emerged in the second half of the twentieth century. Red, black, and white beads initially gained popularity for their similarity in color to locally sourced materials. Green, blue, and yellow beads, featured in corsets like this one, joined this trio later, enabling new color combinations and patterns.[28] The only rigid portions of this beaded corset are the projecting fin or horn worn in line with its wearer's backbone and its metal closure at front. Connecting the front and back are sweeping strings of beads arranged in sections of contrasting colors. The lowermost strings of aqua and white beads are gathered to create a scalloped bottom. This spectacular display does more than just please the eye; such color combinations served to communicate the wearer's age and status within Dinka society.[29]

Today, male corsets and the glass beads that compose them may be casualties of the region's persisting civil war and internal conflict. Dinka communities reside in Africa's newest country, South Sudan, which gained independence in 2011. But many Dinka sold their beaded items and now don tailored clothing, provided by the region's numerous aid organizations and encouraged by Christian missionaries for the sake of modesty.[30] CT

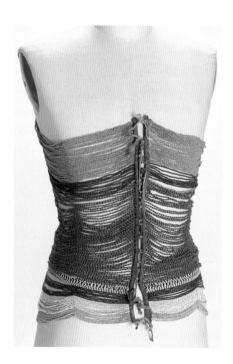

(front) Beaded corset (*malual*), Dinka, South Sudan

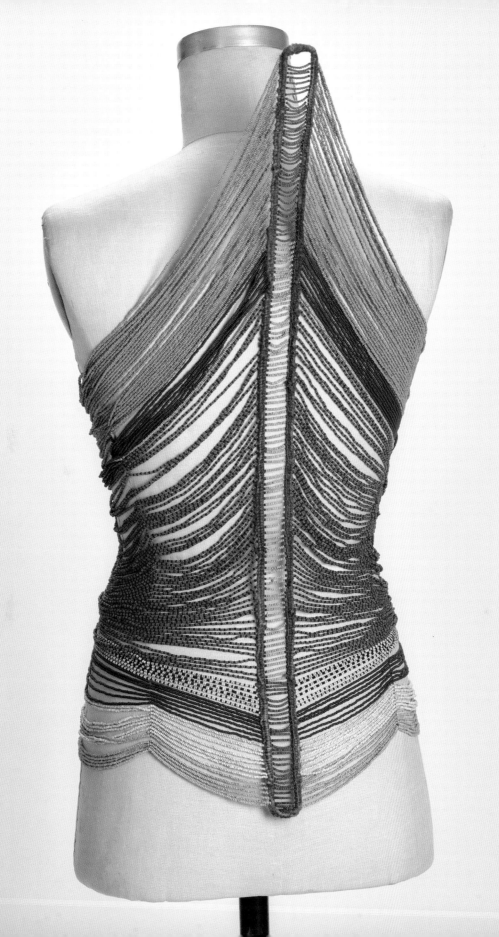

30
Beaded collar

Maasai
Kenya or Tanzania
Glass beads, wire
20th century
15 ½ × 16 ¼ in.
Collection of William D. and
Norma Canelas Roth '65

During the late nineteenth century, East African ethnic boundaries and identities solidified at the same time that an influx of foreign trade goods, notably textiles and beads, entered the region. As a result, the newly defined ethnic groups adopted specific dress customs using these novel trade goods to differentiate themselves from one another. For the Maasai, these defining dress aesthetics were focused on the colors and designs of beaded jewelry.[31]

Maasai women display their personal wealth, status, and familial ties through beadwork. Whereas Maasai men own and tend cattle, women are gifted beadwork on the occasion of their marriage and retain this wealth as their own. Unstrung beads are purchased by a bride's parents, but many women come together to transform loose beads into a bride's beadwork ensemble.[32] This includes collars, such as this one, but also headpieces, an abundance of necklaces, bracelets, wristlets, earrings, anklets, belts, and more. Therefore, beadwork among the Maasai is a presentation not only of personal wealth, but community investment.

Collars such as this one clearly embody a Maasai aesthetic through its iconic color set of red-green-white-orange-blue, which are considered the "beautiful colors," or *muain sidain*.[33] In pairing these contrasting and complementary colors, the Maasai aim to catch the eye and create a vibrant visual impact through bold blocks of color. In addition to their aesthetic power, these colors hold symbolic importance. The red within the color set denotes youth, while the black (here embodied by dark blue beads) symbolizes seniority or the authority of God, and the white signifies protection.[34]

While an exact date is not known for this piece, a study of historic trade events can help to provide an approximation. During the early 1980s, a global shortage of white seed beads influenced Maasai beadworkers to adapt their color set to red-yellow-black in order to avoid the need for white beads.[35] Thus, because this collar exhibits the previous red-green-white-orange-blue combination, it can likely be dated to before the 1980s. MS

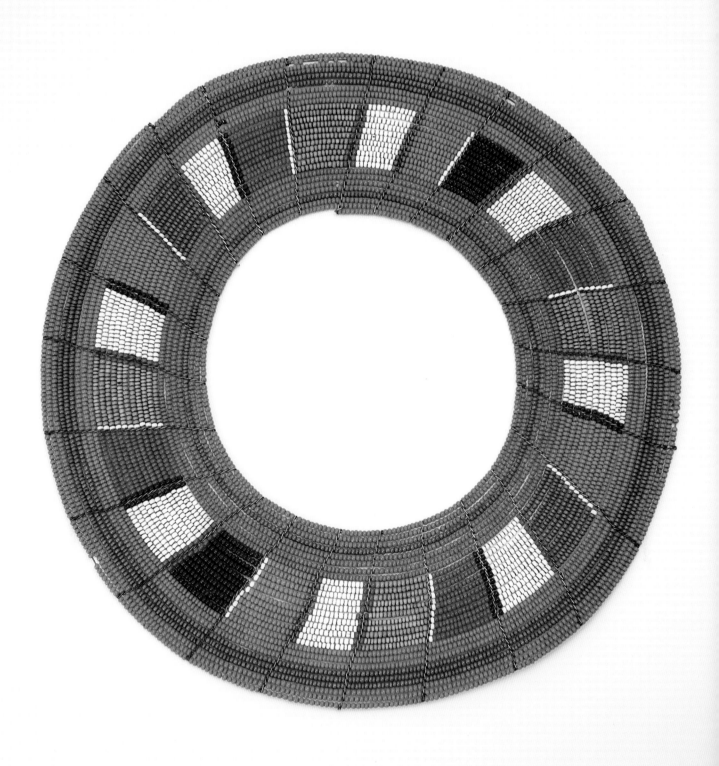

31
Kikoi cloth

Swahili Coast, Kenya
Cotton, synthetic dyes
21st century
38 ½ × 65 in.
Collection of James
and MacKenzie Ryan,
former collection of Patricia Lancaster

Kikoi are rectangular cotton wrappers favored by men across the Swahili Coast of East Africa.[36] They form part of a larger handweaving tradition that spreads across the coastal region, uniting *futa benadir* from Somalia, *kikoi* of Kenya and Tanzania, and *lamba* from Madagascar. Men are typically the weavers of both *kikoi* and *futa benadir* on mainland Africa, while weavers on the island of Madagascar are women.

Kikoi generally feature varying numbers of stripes along its length and fewer perpendicular stripes along its width; their crossing creates a plaid design in each corner. Embracing synthetic dyes in the twentieth century, *kikoi* are now woven from vibrant, machine-spun thread, displaying an array of colors throughout the ground and along the fringed edges. The common designs of stripes and plaid make *kikoi* and its coastal cousins open to meaning, use, and a variety of markets.[37] Today, *kikoi* are marketed not only as men's wrappers, but beach blankets, scarves, wall hangings, and other items of dress and decor. CT

32
Painted bark cloth

Mbuti
Democratic Republic of the Congo
Bark, natural dyes
20th century
16 × 33 in.
Collection of William D. and
Norma Canelas Roth '65

Communities such as the Mbuti of the Democratic Republic of the Congo craft astonishingly flexible and soft material from bark.[38] The creation and decoration of bark cloth is divided but shared equally between men and women. Mbuti men pound moistened bark from the ficus (or fig) tree with a wood or ivory tool until the natural material expands widthwise fivefold.[39] This increases the material's pliability and delicacy, allowing the finished cloth to flex easily. The color of bark cloth can range from deep red to camel tan to cream, depending on the tree's age.

Following pounding, women paint linear designs on the cloth using a stick or their fingers. They use naturally derived pigments: a brilliant red made from gardenia or madder bark or a deep gray made from a mixture of charcoal and fruit juice.[40] Designs seemingly have no deeper meaning but are appreciated for their aesthetic, individualized, and somewhat random qualities.[41] Women paint their bodies with similar linear designs, crafting a shared aesthetic on both skin and cloth.[42]

Bark cloth, while not a woven textile, functions as clothing in the form of dance skirts, women's aprons, men's funerary shrouds, and other ceremonial attire.[43] Women wear two cloths while men pass the cloth between their legs and secure it at their waist with a belt. Made for both personal use and to trade with other communities, bark cloth serves many purposes and relies on the skills of both Mbuti men and women in its creation. CT

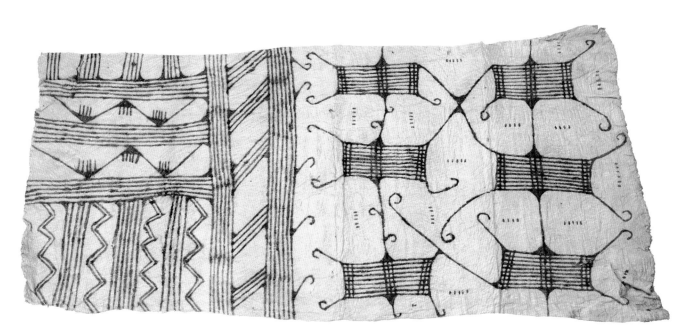

33
Chief's cap (mpu)

Kongo
Democratic Republic of the Congo
Raffia, natural dyes
20th century
3 ½ × 6 ¼ × 6 ¼ in.
Collection of William D. and
Norma Canelas Roth '65

Headwear in the Kongo Kingdom acts as a visual representation of one's position in society, denoting wealth, status, and authority.[44] While this Kongo *mpu* may appear simple in color and design, it is an upper-class prestige cap, bestowed on its owner upon ascension to office.[45] Close-fitting caps like this one are worn by men and women of noble birth, while taller *mpu* are exclusive to the king and chiefs. Even the Kongo word for chief, *mfumu a mpu*, or "chief of the cap," recognizes the power of the *mpu*.[46] Over the centuries, the *mpu* has largely maintained its form and design, withstanding even colonial intrusion by the Portuguese beginning in 1482.[47]

Kongo artists transform natural fibers from raffia, pineapple, and banana plants into delicate, intricate, and understated artistry. Beginning from the center and spiraling outward, artists work with a single strand of fiber and build onto the central string to create the knotting and interlaced patterns typical of *mpu*.[48] The small, dome-shaped cap rests on the crown of the head and highlights its spiral through contrasting natural and brown fibers.[49] Spirals are powerful and resilient symbols in the Kongo Kingdom, serving as metaphors for longevity and continuous existence.[50]

Unlike other examples that feature meandering or interlocking designs, reminiscent of Kongo raffia textiles and carved ivory horns, this *mpu* displays only two rows of raised triangular forms encircling the cap beyond a darker brown spiral at its crest. Its close-fitting form and knotted, embossed triangles may indicate this is a *mpu mafouk*, a cap granted to officials who managed trade with Europeans.[51] Challenging Western conventions of ornate royal crowns, the austere coloring, understated decoration, and modest scale give little hint as to the authority that the cap afforded its wearer. MS

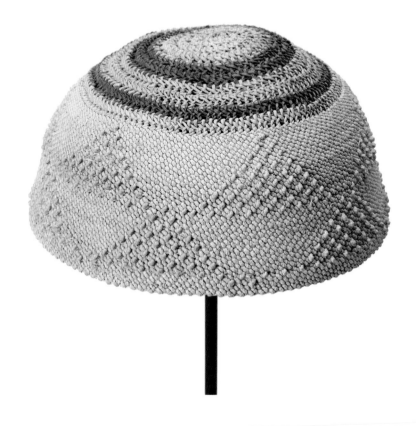

34
Beaded headband

Kuba
Democratic Republic of the Congo
Raffia, glass beads, cowrie shells
20th century
2 × 20 in.
Collection of William D. and
Norma Canelas Roth '65

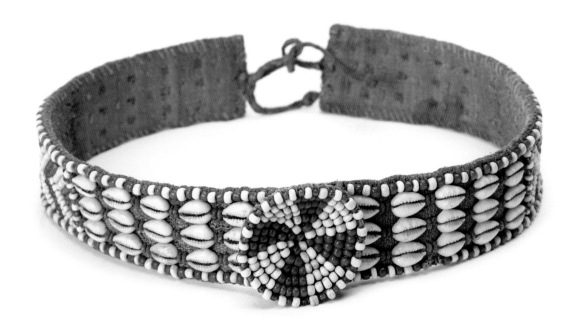

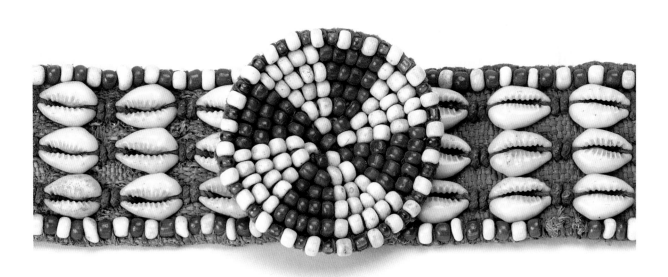

35
Headwear, long dress, and necklaces

Herero
Namibia
Headwear: Polyester cloth, metal pin
Dress: Cotton, silk, and polyester cloth
Necklaces: Glass and plastic beads
on cotton thread
Mid-20th century
Dress: 57 × 38 in.
Headwear: 8 ½ × 18 ½ × 7 in.
Necklaces: 13 × 4 in.
Collection of William D. and
Norma Canelas Roth '65

Gender roles, competition, and the colonial history of the Herero in Namibia and Botswana are made clear through the "long dress" (*ohorokweva onde*).[52] The long dress emerged during Germany's late nineteenth-century colonial rule, during which the wives of missionaries and colonial officials taught Herero women how to sew.[53] Herero women initially resisted converting to Christianity and adopted their new sartorial creations only after a rival African community, the Orlam, did so. Previously, Herero women wore minimal leather clothing. In the shift from leather to the adoption of the long dress, Herero women's distinct apparel maintained its matriarchal authority and cultural significance. [54]

Since the 1880s, young Herero women have adopted the long dress upon entering adulthood, wearing it daily and on formal occasions.[55] The skirt's many layers relate to a woman's communal and familial duties.[56] While the proportions have changed—early twentieth-century long dresses have natural waists and slim skirts, while later twentieth-century versions boast empire waists with exceptionally voluminous skirts—the symbolic meaning remains constant. A rounded midsection represents fertility, while the heavy skirts force wearers to walk with a slow gait that Herero women uphold as proper etiquette.[57] These physical properties also emulate a cow's large physique and steady stride, alluding to the Herero community's pastoral lifestyle and great value placed on their cattle herds.[58]

This long dress reflects a mid-twentieth-century style and recycles older cloth in its patchwork construction. The variety of fabrics include polyester-mix panels of muted red and purple, with softer panels of green and mauve silk, paired with white and black sections and patterned cotton upper sleeves. Accompanied by strings of beads, the long dress ensemble is completed with a butter-yellow headpiece (*otjikaiva* or *otjituku*), its horizontal projections mimicking cattle horns.[59] Later headdresses incorporate a horizontal wooden base to form wider projections, further connecting the symbolic value of women to that of cows. ᴄᴛ

36
Marriage blanket (*nguba*)

Ndebele
South Africa
Glass beads, wool blanket, cotton thread
ca. 1970s
41 × 62 in.
Collection of William D. and
Norma Canelas Roth '65

Ndebele women of South Africa's Transvaal province have used elaborate glass beadwork to express their individuality, artistry, and wealth throughout the twentieth century, and they continue to do so today. Continuities in aesthetics—the geometric, abstracted designs; bold colors; and sharp edges—are shared between Ndebele beadwork adornment and mural paintings on houses. Ndebele women are the artists and owners of these complementary artistic traditions, which have adopted new color combinations and motifs across the last century.

Marriage blankets (*nguba*) use imported wool blankets as their base. Colorful in their own right, wool blankets desired by Ndebele women possess vertical stripes of green, red, blue, yellow, and purple with a vibrancy made possible through synthetic dyes. Individually beaded panels composed of imported glass seed beads are affixed to the wool blanket ground. These beaded panels often finish in open-work patterns and overlap to create a series of flaps, which to the eye read as a progression of horizontal registers. The top register incorporates Roman letters, desirable for their graphic qualities, while subsequent registers possess geometric, abstracted designs in a largely symmetrical composition. Despite their substantial weight,

married women wear the blankets wrapped around their shoulders in a cape-like fashion. Worn with a multitude of other Ndebele beaded adornments, women proudly display their wealth, status, and artistry on their bodies.[60]

Ndebele women both produce and receive the blankets upon their weddings, continually adding panels of beadwork to commemorate important moments in their lives. Older beaded panels may be gifted by family members and incorporated into blankets that include the latest trends in bead colors and threaded motifs. This allows for artists to embrace mid-century motifs and color schemes—such as houses and light bulbs set against a white field, as in Ndebele mural painting—or later aesthetic preferences, as this blanket does with its predominantly iridescent, jewel-tone beadwork.

The transformation to a jewel-tone beaded aesthetic emerged around the 1970s, when lustrous blue, green, and purple beads set against a black field became a popular color palette.[61] The larger, plastic, green beaded edges also help date this example, showcasing a new import item and trend characteristic of the decade. Ndebele pieces made a generation earlier around mid-century tend to consist of opaque primary and secondary colors, especially red, blue, yellow, green, and orange on a field of white, with some figural elements.[62] Early twentieth-century examples are predominantly white, with simplified geometric motifs and a focus on open-work beading. CT

Marriage blanket (detail), Ndebele, South Africa

Generational Conflict
and Continuity

Entries 37–54

37
Amber necklace

Imazighen
Morocco
Amber, silver, felt, silk thread
20th century
19 ¼ in.
Collection of William D. and
Norma Canelas Roth '65

Understated yet striking, this necklace, composed of large amber beads and red felt protective fillers, would have likely been worn by an Amazigh woman from Morocco's Middle Atlas region.[1] Like the highly valued silver used in Amazigh women's fibulae, amber is prized by the Imazighen and thus incorporated into significant jewelry pieces. The Imazighen believe that amber protects its wearer against disease and exhibits medicinal and healing properties.[2] In light of this, amber necklaces are often included in an Amazigh bride's elaborate wedding day ensemble, both for their aesthetic appeal and protective qualities. Furthermore, amber beads, along with pieces of gazelle horns, denote wealth and prestige within Amazigh society; thus, beads are often used in women's and even children's jewelry as symbols of prosperity.[3]

This precious aspect of amber not only resides in its powerful properties, but in its scarcity. Traded throughout the Mediterranean world since ancient times, true amber, produced from fossilized pinesap, is rare and costly, affording it great monetary and cultural value.[4] Because of this, less expensive substitutes, such as copal, amberoid, and Bakelite, are often used in jewelry.[5] Many large, Moroccan "amber" beads are in fact made of copal,[6] which is produced from semifossil amber and found along the west coast of Africa.[7] However, the necklace illustrated here is genuine amber, apparent from its rich, honey-colored hue, irregular cracks and bubbles, and slight warmth to the touch. MS

38
Royal headband and sandals

Asante
Ghana
Headband: Velvet, wood, gold leaf
Sandals: Leather, wood, velvet, gold leaf
20th century
Headband: 3 ¼ × 10 ¾ in.
Sandals: 5 × 11 ¼ × 3 ½ in.
Collection of William D. and
Norma Canelas Roth '65

Akan-speaking communities in southern Ghana and Côte d'Ivoire reserve gold-embellished sandals and black velvet headbands for their chiefs and kings, befitting of the region's moniker and former colony name, the Gold Coast.[8] The Asante Kingdom, a dominant regional force throughout the eighteenth and nineteenth centuries, continues to use both headbands and sandals in the royal apparel of the *Asantehene*, the king or paramount chief. The adornments affixed to these accessories are either cast from gold or sculpted from wood covered in gold leaf, as these examples demonstrate. As with Asante kente cloth designs, the shapes possess symbolic meaning and refer to proverbs. More generally, headbands and sandals serve as emblems of wealth and status and are worn with wrapped kente or other prestige cloth as well as a preponderance of gold bracelets, rings, necklaces, and anklets.

An Akan chief's or *Asantehene*'s pair of sandals, however, are not one of a kind; in fact, the sheer size of his sandal collection serves to demonstrate his worth. Ten or twenty pairs of sandals are enough to incite awe in onlookers, especially in the case of the *Asantehene*, who wears and includes sandals in his ceremonial processions. Surrounded by equally extravagant court officials, these processions exemplify the symbolic power of Akan titleholders. Sandals carried in front of the *Asantehene* are of special significance, while the placing or removal of sandals on a king's feet marks a transition in his authority. Placing sandals on his feet is a part of his enstoolment, or enthronement, ceremony; removing sandals from his feet displays his deposal from the throne. In the latter case, his feet then touch the same ground as laymen, thereby stripping him of a subtle yet clear marker of his rank and status.

The considerable wear on this pair of royal sandals, evident in their flattened patches of velvet and flaking gold leaf, helps connect an individual's lived experience with that of the collective. Though diminished in the twentieth century, first by British colonial rule and subsequently by independence movements, the *Asantehene* still plays an important role in Ghana today, linking a long and glorious past with the present. CT

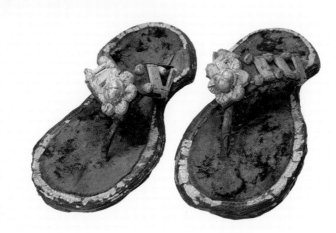

39
Kente cloth

Asante
Ghana
Silk, synthetic dyes
20th century
122 ¾ × 81 in.
Collection of William D. and
Norma Canelas Roth '65

40
Kente cloth

Ewe
Ghana
Cotton, synthetic dyes
20th century
114 × 62 in.
Collection of William D. and
Norma Canelas Roth '65

The prevalence of kente cloth in Africa and the African diaspora today attests to its use as a symbol of heritage and pride.[9] In the late nineteenth century, the acquisition and wearing of wrapped kente was limited to Asante royal titleholders and wealthy Ewe individuals in West Africa. In the mid-twentieth century, emerging African leaders adopted kente patterns and, in turn, tied the cloth's bold, geometric, and densely woven designs to burgeoning independence movements and surging pride in African heritage. Ghana, home to both Asante and Ewe weavers, was the first sub-Saharan African nation to gain its independence from European colonial rule in 1957 and became a model for other independence movements. As such, today's kente patterns possess meaning in Ghana, across Africa, and throughout the African diaspora.

The weaving of kente has also changed throughout the twentieth century, though weavers consistently display mastery in strip-woven cloth by incorporating virtuosic supplementary weft float designs. Extant nineteenth-century examples are limited in color to natural cotton and indigo blue, with some red silk and relatively basic designs. In the early twentieth century, both Asante and Ewe weavers adopted new color possibilities courtesy of synthetic dyes, applied them to different fibers, and increased the supplementary weft float patterning throughout. Asante kente uses imported silk threads (and later, rayon, an artificial alternative) dyed in bright, saturated colors to give their woven cloths a soft sheen and delicate drape. Ewe kente uses synthetically dyed cotton thread, lending their woven cloths a more matte surface and thick drape.

While both of these kente cloths possess allover patterns created through tightly woven strips assembled into large cloths, Asante designs typically encompass zigzags, bold stripes, and rhombus shapes. Ewe designs utilize a variety of vertical and horizontal striping and many more colors. Where the Asante kente is predictable in its repeating pattern, the Ewe kente includes surprises in its woven square designs. While these impressive cloths are the products of many hours, days, and even weeks of effort, kente patterns (often aligning with Asante aesthetics) are common in factory-printed cloths, widely available in West Africa and throughout the diaspora. Differing in meaning, use, and creation across time and space, kente continues to serve as cloth rife with meaning and value to its wearers. CT

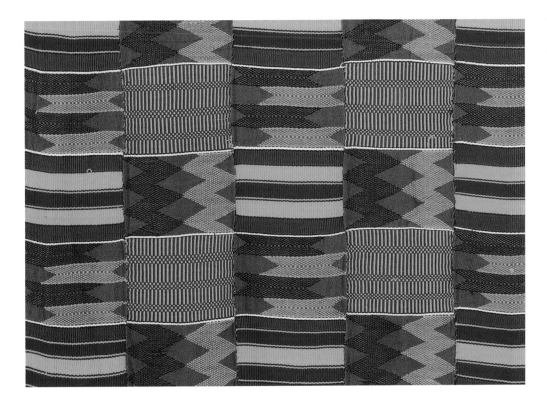

Kente cloth (detail),
Asante, Ghana

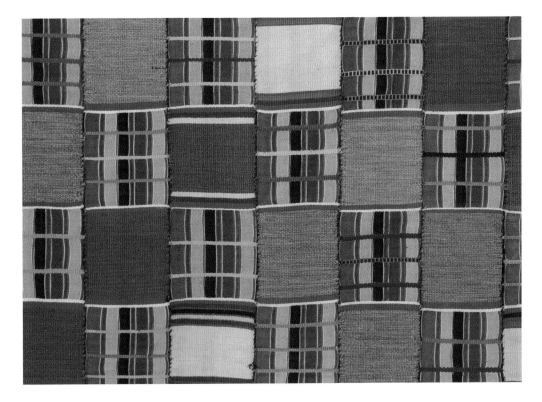

Kente cloth (detail),
Ewe, Ghana

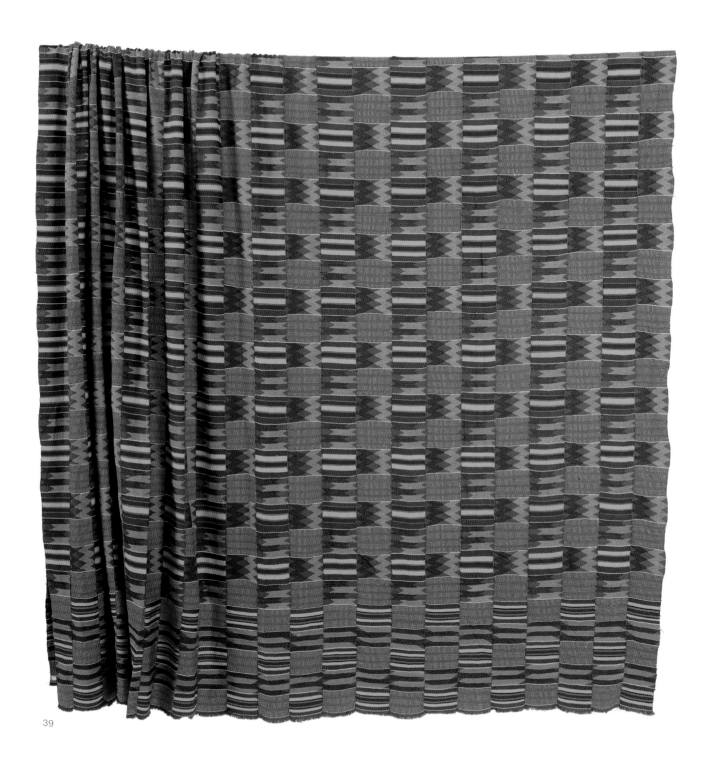

39

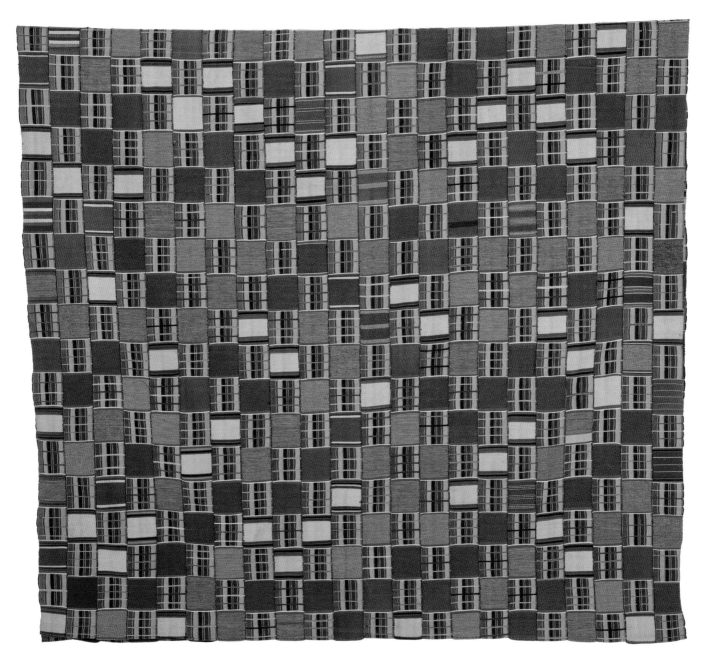

40

41
Indigo *riga*

Hausa
Nigeria
Cotton, cotton embroidery, indigo dye
20th century
53 × 101 in.
Collection of William D. and
Norma Canelas Roth '65

42
Red *riga*

Hausa
Nigeria
Cotton, silk embroidery, synthetic dyes
20th century
51 ½ × 86 ¾ in.
Collection of William D. and
Norma Canelas Roth '65

Men's mastery of strip-weaving, indigo dyeing, and embroidery work coalesce in West African *rigona*, or large robes.[10] Worn by men for daily attire and special occasions, *rigona* serve as a wardrobe staple of elite men and draw upon a shared Islamic heritage.[11] European accounts of impressive *rigona* date back to the mid-seventeenth century and likely gained widespread appeal during the early nineteenth-century Islamic reform movement led by Usman dan Fodio. Dan Fodio established the Sokoto Caliphate among the Hausa in northern Nigeria, which lasted from 1809 to 1903. Men across West Africa continue to wear embroidered robes today, suggesting impressive continuity. Two versions here demonstrate the Hausa style and possess similar embroidered motifs, though they differ in color, woven design, and silhouette.

Both *rigona* are composed of narrow strips of handwoven cotton cloth. Specialist weavers produced strips of cloth with woven patterns on horizontal looms; here, the red *riga* possesses narrow yellow and green stripes, while the indigo-dyed *riga* displays a faint white plaid. Hausa men are renowned for their expertise in natural indigo dyeing, and professional embroiderers apprentice for many years before fulfilling commissions of their own. Often, embroidery is stitched from silk thread, adding another layer of prestige to the skillful embellishment.

Both *rigona*'s hand-stitched embroidery draw from a corpus of Islamic motifs. The two, elongated triangles below the yoke form the two daggers or *aska biyu* motif, which offers its wearer protection.[12] The spiral pattern, found on the wearer's right chest and repeated across the upper back is known as the drum or *tambari* design, and protects against envy, or "the evil eye" of others.[13] The stitches themselves create openwork that allow the saturated color of the dyed cotton robe to peek through, reminiscent of lacework and dissimilar to the densely packed stitches of the majority of embroidered designs. This demonstrates the embroiderers' multitude of techniques and, in turn, the wearer's elite status.

The red *riga*'s sleeves are differentiated from its torso, but the indigo *riga*'s sleeves and torso meld into one largely untailored garment. Both voluminous *rigona* create the visual illusion that the wearer's body is broader than it is.[14] This effect is amplified when the wearer moves, setting his entire ensemble—the *riga*, under-tunics or shirts, and loose trousers—in billowy motion.[15] Its generous dimensions help to convey power within an Islamic context. The long-standing tradition of *rigona* suggests a value of generational continuity over novelty, what endures over what is trending. CT

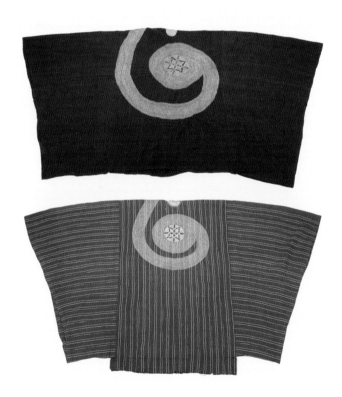

Top: Indigo *riga* (verso), Hausa, Nigeria; Bottom: Red *riga* (verso), Hausa, Nigeria

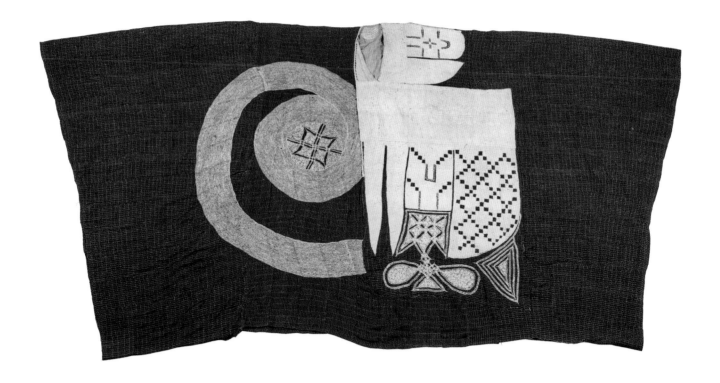

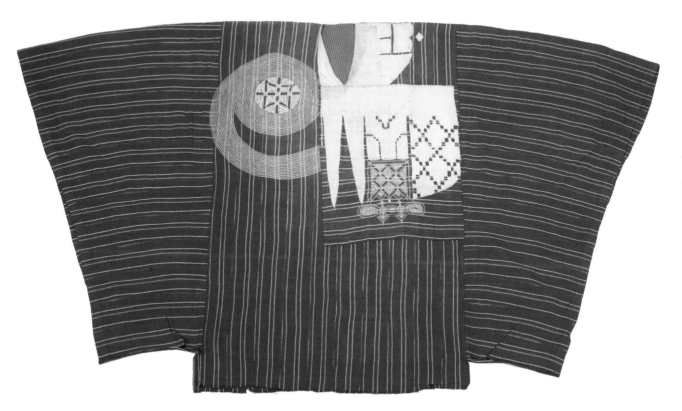

43
Metal filigree necklaces
and bracelet

Fon
Republic of Benin
Brass
20th century
(below) Necklace with soldered stars
pendant: 15½ × 2¼ in.
(right) Necklace with floral pendant:
18 × 3½ in.
Bracelet: 3½ × 3 × 2¼ in.
Collection of William D. and
Norma Canelas Roth '65

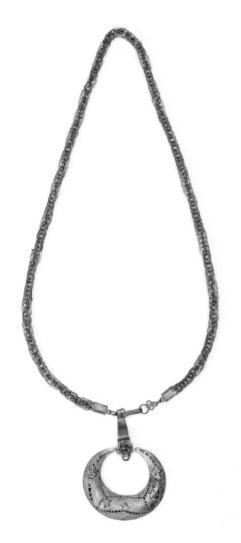

44
Hand-pounded
silver necklace

Oromo
Ethiopia
Silver beads, cotton thread
19th century
14 in.
Collection of William D. and
Norma Canelas Roth '65

45
Appliqué tunic (*jibbeh*)

Mahdi
Sudan
Undyed cotton cloth with blue wool
and red cotton patches
Late 19th century
37 × 51 in.
Collection of William D. and
Norma Canelas Roth '65

Tunics from the Sudan with geometric patches of appliqué, referred to as *jibbeh*, embody the region's conflict-ridden history, emerging out of the late nineteenth-century wars between Sudanese Muslims and ruling Egyptian elites and British colonial officials. Army officers for the Mahdi, the "Divinely Inspired One," wore such tunics as their uniforms while they fought Egyptian authorities supported by forces from Britain.[16]

Muslim mystic Muhammad Ahmad of Dongola, a region in Sudan, took the title Mahdi in 1881 after experiencing divine revelations. He began an Islamic jihadist movement which lasted from 1881 to 1898 against the Egyptian ruling class and their British backers, advocating for a more orthodox Islamic state and liberation from foreign rule.[17] Upholding Mahdist principles of poverty and asceticism, the Mahdi's initial followers donned tattered and patched tunics.[18] While still an early example, this *jibbeh* represents how an initial necessity, patching and repairing garments, became a stylized uniform to show its wearer's allegiance to the Mahdist reform movement.

Akin to its aesthetic power, the *jibbeh*'s confluence of materials marks its historical moment in time. This tunic bears a base of undyed, strip-woven cotton; an interior of coarse, cotton strips; and patches of industrially woven and imported cloth, sewn by machine. These appliqué patches demonstrate sought-after materials at the turn of the twentieth century—imported, manufactured cloths and the use of sewing machines, a departure from the original threadbare *jibbeh*. The red cotton and blue wool patches line the front, reverse, sides, and shoulders, making the tunic bilaterally symmetrical; such symmetry served a powerful Islamic protective function, ideal for military officers. CT

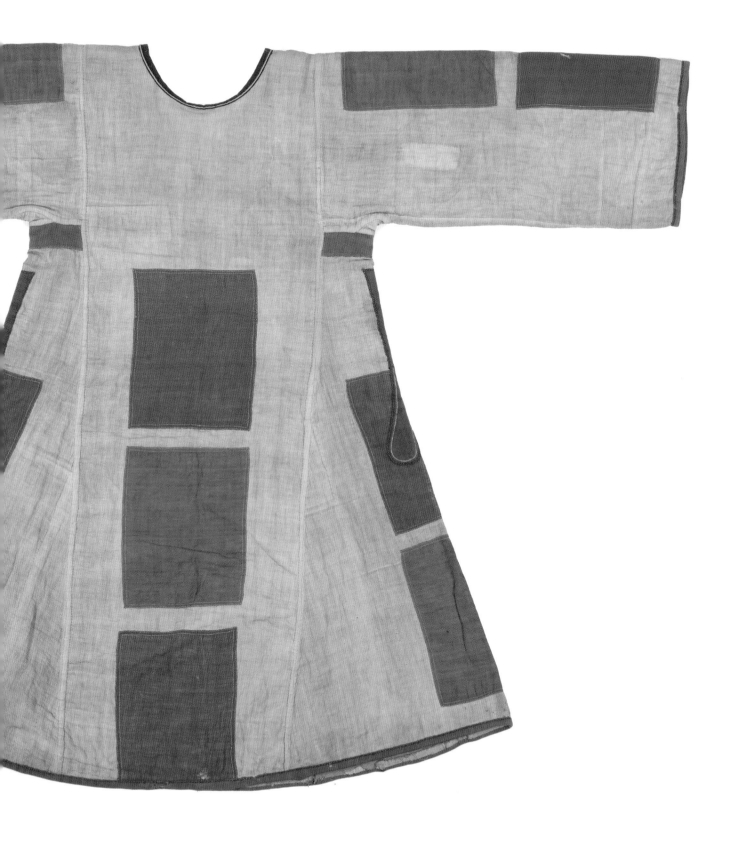

46
Raffia cut-pile skirt with embroidery

Kuba
Democratic Republic of the Congo
Raffia, natural dyes
20th century
29 ½ × 63 ¾ in.
Collection of William D. and
Norma Canelas Roth '65

47
Raffia cloth with openwork and embroidery

Kuba
Democratic Republic of the Congo
Raffia, natural dyes
20th century
24 × 56 ½ in.
Collection of William D. and
Norma Canelas Roth '65

From raffia, a rough natural material sourced from palm leaves, Kuba weavers of the present-day Democratic Republic of the Congo create pliable textiles with precise yet syncopated geometric patterns. One such iconic form of these raffia cloths is created through the technique of cut-piling, in which Kuba women cut the ends of embroidery stitched into a textile base (woven by men) to produce a raised detail similar to velvet.[19] This exact and tedious method is exclusive to women, and the resulting designs testify to women's historical practice of Kuba embroidery.[20] Passed down from one generation to the next, Kuba velvet patterns exhibit the continuity and ingenuity of design across female family lines.[21] Because of this, a woman's knowledge and repertoire of patterns is somewhat limited to that of her mother and grandmother. However, she can also invent new designs and arrangements from her familial set of patterns, exemplifying the Kuba ideal of artistic innovation.[22]

Finely and intricately woven, the Kuba cut-pile textile featured here evidences the artistic prowess of the woman who crafted it, displaying her expertise in both cut-pile and embroidery. The lively, meandering pattern of the dense raffia velvet is delineated with careful lines of embroidery and interrupted by vibrant diamonds of green velvet. This central panel of velvet is then framed by an equally embellished border of pure embroidery, mirroring the cut-pile in design but punctuated with bold, black lines and finished with a rich, red hem.

Produced by women, this textile would have also been worn by women—wrapped several times around the waist and belted to form a skirt,[23] which would be worn at ceremonial events such as dances and funerals.[24] The second Kuba textile, which has an unusual, deep burgundy hue, would likely have been a funerary cloth for a wealthy dignitary. Like the skirt, this cloth features fine embroidery. However, it is unique in its delicate openwork, which lends it a lace-like appearance, and the black and tan pom-poms that ornament its hem, which symbolize male wealth. MS

Raffia cut-pile skirt with embroidery (detail), Kuba, Democratic Republic of the Congo

Raffia cloth with openwork and embroidery (detail), Kuba, Democratic Republic of the Congo

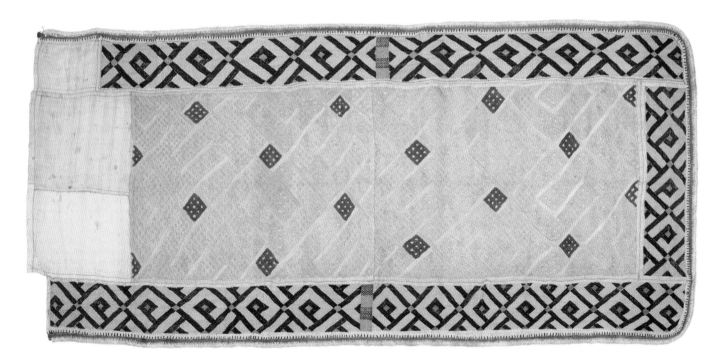

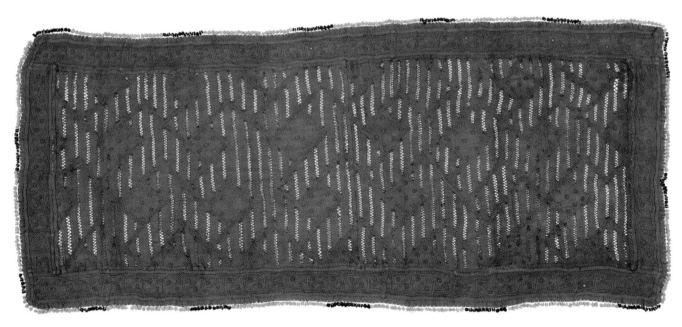

48
Headddress *(ekori)*

Himba
Namibia
Leather, ocher dye, metal beads
20th century
21 ½ × 16 × 10 in.
Collection of William D. and
Norma Canelas Roth '65

The Himba in northern Namibia's desert Kaokoland region rely on local resources and personal wealth to construct their leather dress items, from belts to aprons to headdresses *(ekori)*.[25] The pastoralist Himba apply ocher with a mixture of animal fat, sediment, and plant-based materials to calfskin leather.[26] The red, claylike ocher substance protects the leather from heat and sunlight and possesses a particular aroma. The Himba also cover their skin and hair in ocher for these protectant and cosmetic purposes, which in turn gives their skin the same brick-red sheen.[27]

In light of the Himba's dependence upon natural materials and their seminomadic lifestyle as cattle keepers, the Himba have been exposed to global influences. This headdress has silver pounded beads pressed into the leather attachments that surround the wearer's face and sit atop her head. Such beads are frequently derived from the remnants of rifle cartridges and hand grenade pins, reminders of Namibia's decades-long wars for independence, first from German rule at the beginning of the twentieth century and then from South Africa—only achieved in 1990.[28]

Embodying generational continuity in the face of political conflicts, these leather headdresses also embody Himba gender dynamics.[29] Himba brides receive the *ekori* that were used in their matriarchal ancestors' own marriage ceremonies. Brides wear them during their first month of wifehood, while those worn after that period serve as symbols of fertility. If a wife dies, her widower is then tasked with returning her headpiece to her mother or sisters.[30] The *ekori* is exchanged between a wife's and husband's families as a gesture of respect and new beginnings, like the cattle that play such an integral role in Himba and other pastoralist societies. CT

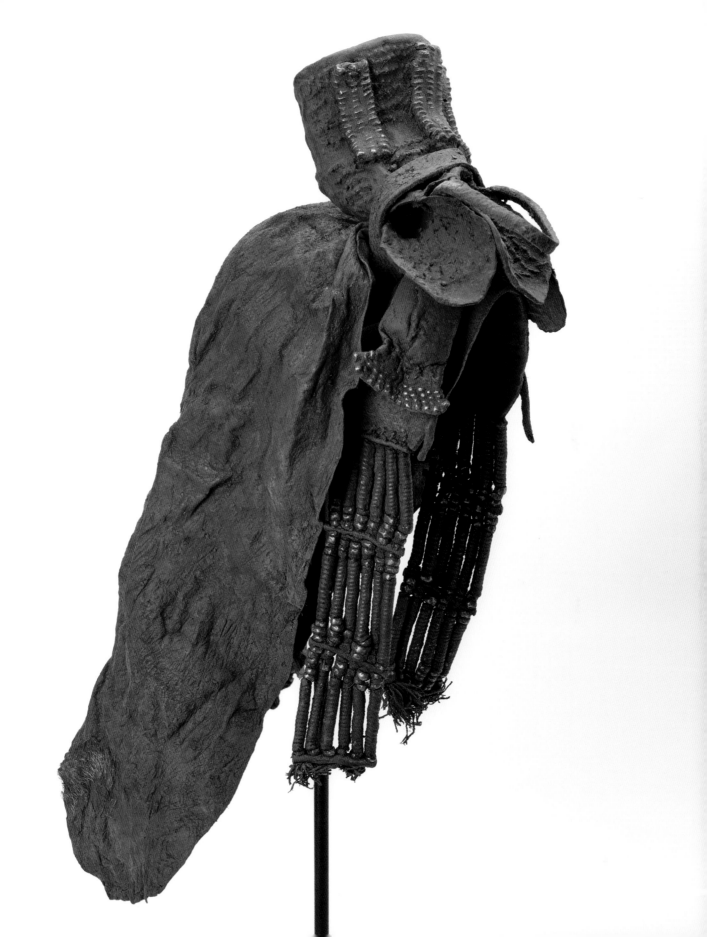

49
Child's apron

Ndebele
South Africa
Glass beads, canvas
Mid-20th century
13 ¾ × 17 in.
Collection of William D. and
Norma Canelas Roth '65

50
Child's doll

Ndebele
South Africa
Glass beads, sisal, cotton thread
Mid-20th century
9 × 5 × 4 in.
Collection of William D. and
Norma Canelas Roth '65

Ndebele women create and wear their beaded art forms as clothing and adornment.[31] Their bold, graphic, and geometric beadwork patterns embellish items from marriage aprons, thick anklets, bangles, and necklaces, to items intended for children, including this child's apron and doll.[32] Threaded glass beadwork all but obscures the apron's canvas and doll's sisal rings. Canvas serves as a cheaper alternative to leather, more often used in adult apparel, reflecting the artist's priority of function and strength in order to help the apron withstand the carefree and cavalier nature of youth.

The solid-colored beaded rings that form the doll's body mimic the beaded anklets, bangles, and necklaces commonly worn by Ndebele women. The doll itself functions as a promoter of fertility, indicator of marriageability, and tourist market commodity.[33] The geometric designs that adorn the apron are characteristic of mid-twentieth-century Ndebele beadwork, formed from primary colors outlined in black on a ground of white beads. This aesthetic is evident in Ndebele women's mural paintings, inspired by beadwork, which use commercial paint to enliven the exterior walls of their residences.[34] From geometric house painting to crafting clothing and accessories for children, Ndebele women continue to innovate while passing down their talents to the next generation. CT

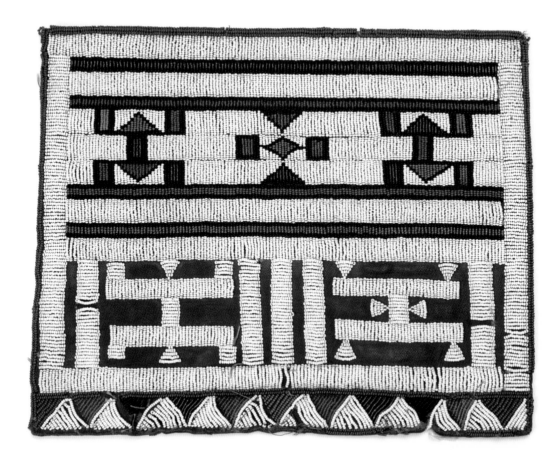

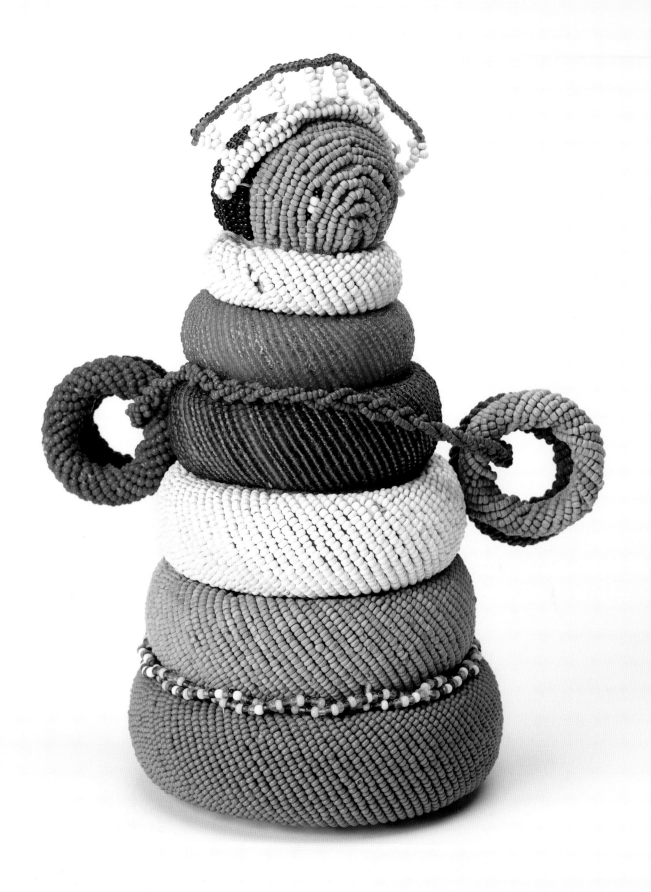

51
Ostrich eggshell necklace

San
South Africa
Ostrich eggshell beads, twine
20th century
13 in.
Collection of William D. and
Norma Canelas Roth '65

Beaded apron

Bhaca
South Africa
Glass and plastic beads, cotton thread,
metal bells
Mid- to late 20th century
9 × 5 ½ in.
Collection of William D. and
Norma Canelas Roth '65

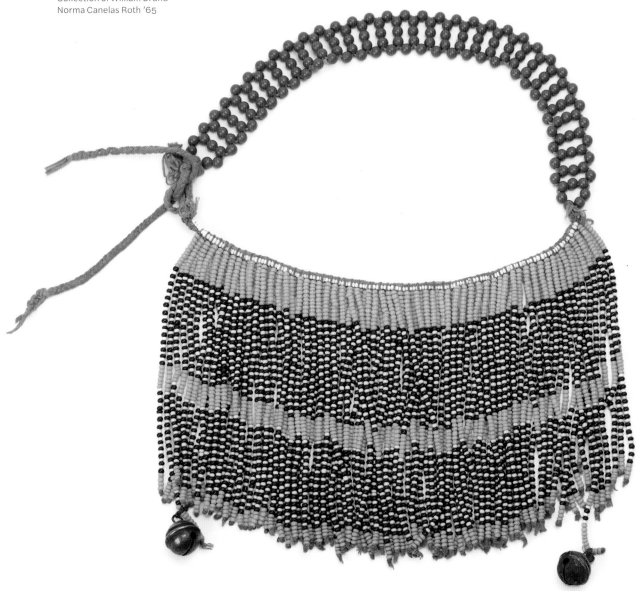

53
Beaded waistcoat

Zulu or Tsonga
South Africa
Glass beads, waistcoat
ca. 1970s
26 ¼ × 18 in.
Collection of William D. and
Norma Canelas Roth '65

Whereas waistcoats are typically hidden beneath one's coat, this significantly embellished example from South Africa is clearly meant to command attention. This manufactured and tailored men's waistcoat features a preponderance of glass-beaded adornment. Owned by a Zulu or Tsonga man, the beadwork was likely the work of his wife, for it is women across the region who create beaded items of apparel for themselves and their families.

Akin to other beadwork designs from the Zulu and Tsonga, the back of this waistcoat is characterized by repeating geometric forms, openwork threading, and glass beads in primary and secondary colors.[35] This waistcoat's dominance of white beads accented with red, blue, and green designs of zigzags and diamonds is featured on the beadwork of both communities. While the front of the waistcoat continues this theme of repetition, it instead employs four or five half-circles of white beads, which dangle loosely and frame one another, revealing the brown fabric foundation.

Prior to the mid-twentieth century, a Zulu man's daily outfit typically consisted of materials derived from animals and metals.[36] Beadwork was largely provided to men by women, with married men reserving it for specific settings.[37] With the advent of migrant labor in mid-twentieth-century South Africa, wives began to send their husbands beaded items to maintain contact during long periods apart. This increase in intricate beaded attire in a man's wardrobe communicated to others that he was married.[38]

These colorful, heavily beaded waistcoats were popular among married men around the 1970s and show how South African beadwork traditions were updated to reflect the demands of a new generation of wearers.[39] CT

54
Telephone wire cap

Zulu
South Africa
Plastic-covered telephone wire
Late 20th century
5 × 10 ½ × 7 ½ in.
Collection of William D. and
Norma Canelas Roth '65

The use of telephone wire in Zulu art stems from women's fiber baskets and beer pots. For generations, women have coiled beer pots using clay and interlaced strands of fibers to create baskets. A similar interlace method is used to create items of plastic-covered telephone wire, but in this instance, the art form was pioneered by Zulu men.[40] Since their inception, telephone wire objects have served more as cultural symbols and tourist commodities than functional containers or apparel.[41]

In the 1980s, mine workers and migrant laborers in the KwaZulu-Natal province of South Africa returned home with these innovative objects. Women soon adopted the new material of plastic-covered telephone wire, supported by a community art center in Durban, the Bartel Arts Trust, which presented basketmaking as a creative outlet rather than one of necessity.[42] Plastic-covered telephone wire allowed for more color variation and new motifs and shapes. Before neon oranges, greens, and reds were combined in hypnotic spirals and geometric designs, as seen in this wire cap, women used grasses of different shades to form contrasting patterns.

This cap is perhaps less than practical, with its rigid structure and relatively large size. Its succession of wide blocks of solid colors, thin lines, and long dashes are arranged in spirals unwinding from the crown. The cap's emphasis on bright color, repetition, and shape aligns with the visual power of Zulu beadwork. Conveying continuities in aesthetics while adapting to new materials, markets, and forms, telephone wire hats such as this illustrate Zulu creativity in crafting items of apparel, regardless of whether such creations were put to everyday use. CT

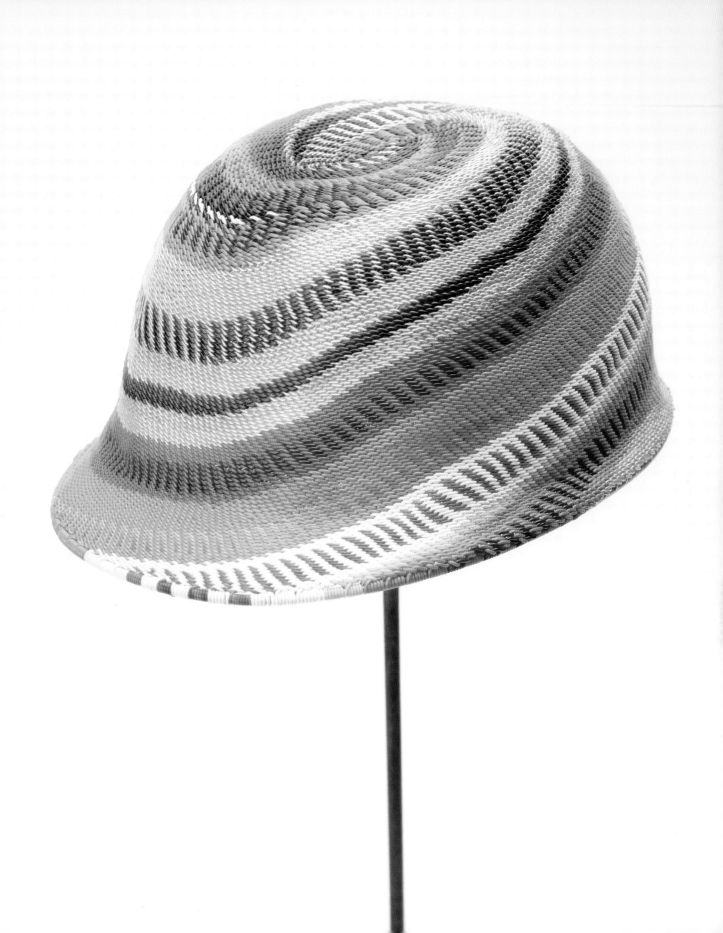

Notes

The Artistry of African Apparel

1. Roger McKay, "Ethiopian Jewelry," *African Arts* 7, no. 4 (1974): 36.

2. Brinkley Messick, "Subordinate Discourse: Women, Weaving, and Gender Relations in North Africa," *American Ethnologist* 14, no. 2 (1987): 213.

3. Robert K. Hitchcock, "Ostrich Eggshell Jewelry Manufacturing and Use of Ostrich Products among San and Bakgalagadi in the Kalahari," *Botswana Notes and Records* 44 (2012): 93.

4. Anitra Nettleton, "Women, Beadwork and Bodies: The Making and Marking of Migrant Liminality in South Africa, 1850–1950," *African Studies* 73, no. 3 (2014): 342–43, 345.

Global Interactions

1. Niloo Imami Paydar and Ivo Grammet, *The Fabric of Moroccan Life* (Indianapolis: Indianapolis Museum of Art, 2002), 48.

2. Horace M. Miner, "Traditional Mobility among the Weavers of Fez," *Proceedings of the American Philosophical Society* 117, no. 1 (1973): 21–22.

3. Paydar and Grammet, *Fabric of Moroccan Life*, 47.

4. Christopher Spring and Julie Hudson, *North African Textiles* (Washington, DC: Smithsonian Institution Press, 1995), 61.

5. John Gillow, *African Textiles: Color and Creativity across a Continent* (New York: Thames & Hudson, 2009), 137.

6. Paydar and Grammet, *Fabric of Moroccan Life*, 108.

7. Gillow, *African Textiles*, 137.

8. Ibid.

9. Ibid.

10. Paydar and Grammet, *Fabric of Moroccan Life*, 108–9.

11. Georgina Herrmann, "Lapis Lazuli: The Early Phases of Its Trade," *Iraq* 30, no. 1 (1968): 21–22.

12. Lois Sherr Dubin, *The History of Beads: From 100,000 B.C. to the Present*, rev. and expanded ed. (New York: Abrams, 2009), 30.

13. Joan Crowfoot Payne, "Lapis Lazuli in Early Egypt," *Iraq* 30, no. 1 (1968): 58.

14. Dubin, *History of Beads*, 129.

15. Susan Cooksey, "Tracing the Routes of Indigo: Four Textiles from West Africa," in *Africa Interweave: Textile Diasporas*, ed. Susan Cooksey (Gainesville: Samuel P. Harn Museum of Art, University of Florida, 2011), 20.

16. Ibid.

17. Ibid., 21.

18. Christopher B. Steiner, "Another Image of Africa: Toward an Ethnohistory of European Cloth Marketed in West Africa, 1873–1960," *Ethnohistory* 32, no. 2 (1985): 92.

19. "About Vlisco," Vlisco, accessed March 28, 2019, https://www.vlisco.com/about/about-vlisco.

20. Nina Sylvanus, *Patterns in Circulation: Cloth, Gender, and Materiality in West Africa* (Chicago: University of Chicago Press, 2016), x, 5.

21. Steiner, "Another Image of Africa," 93.

22. "History of Nigerian Currency," Central Bank of Nigeria, accessed March 28, 2019, https://www.cbn.gov.ng/Currency/historycur.asp.

23. Moyo Okediji, "Art of the Yoruba," *Art Institute of Chicago Museum Studies* 23, no. 2 (1997): 169.

24. Henry John Drewal et al., *Beads, Body, and Soul: Art and Light in the Yorùbá Universe* (Los Angeles: Fowler Museum of Cultural History, University of California, 1998), 201.

25. Ibid., 17.

26. Robert Farris Thompson, "The Sign of the Divine King: An Essay on Yoruba Bead-Embroidered Crowns with Veil and Bird Decorations," *African Arts* 3, no. 3 (1970): 8.

27. Temilola Alanamu, "Yoruba Childhood," *Transition*, no. 121 (2016): 93.

28. Drewal, *Beads, Body, and Soul*, 68.

29. Okediji, "Art of the Yoruba," 170.

30. "Diviner's Bag (*Apo Ifa*), 20th century," The Metropolitan Museum of Art, accessed March 28, 2019, https://www.metmuseum.org/art/collection/search/318332.

31. Drewal et al., *Beads, Body, and Soul*, 229.

32. "Tapper (*Iroke Ifa*)," Art Institute of Chicago, accessed March 28, 2019, https://www.artic.edu/artworks/155958/tapper-iroke-ifa.

33. Drewal et al., *Beads, Body, and Soul*, 229.

34. Ibid., 78.

35. Ibid., 229.

36. *Ukara: Ritual Cloth of the Ekpe Secret Society* (Dartmouth: Hood Museum of Art, 2015).

37. David Heathcote, "Hausa Embroidered Dress," *African Arts* 5, no. 2 (Winter 1972): 18, 81.

38. Royal display cloth (*ndop*), Cameroon, Grassfields Region, twentieth century, The Metropolitan Museum of Art, New York, 2013.1140.15.

39. Dominique Malaquais, "A Robe Fit for a Chief," *Record of the Art Museum, Princeton University* 58, nos. 1/2 (1999): 22.

40. Anne-Marie Bouttiaux, ed., *African Costumes and Textiles from the Berbers to the Zulus* (Milan: 5 Continents Editions, 2008), 154.

41. Ibid., 158.

42. Gillow, *African Textiles*, 182.

43. Ibid., 204.

44. MacKenzie Moon Ryan, "The Emergence of the *Kanga*: A Distinctly East African Textile," in *Africa Interweave: Textile Diasporas*, ed. Susan Cooksey (Gainesville: Samuel P. Harn Museum of Art, University of Florida, 2011), 128–31.

45. MacKenzie Moon Ryan, "Converging Trades and New Technologies: The Emergence of *Kanga* Textiles on the Swahili Coast in the Late Nineteenth Century," in *Textile Trades, Consumer Cultures, and the Material Worlds of the Indian Ocean: An Ocean of Cloth*, ed. Pedro Machado, Gwyn Campbell, and Sarah Fee (London: Palgrave-Macmillan, 2018), 253–86.

46. MacKenzie Moon Ryan, "Kanga Textile Design, Education, and Production in Contemporary Dar es Salaam, Tanzania," *Textile Society of America Symposium Proceedings* (Crosscurrents: Land, Labor, and the Port; Textile Society of America's 15th Biennial Symposium, Savannah, GA, October 19–23, 2016), 424.

47. MacKenzie Moon Ryan, "The Art of the Trade: Merchant and Production Networks of *Kanga* Cloth in the Colonial Era," in *World on the Horizon: Swahili Arts Across the Indian Ocean*, ed. Prita Meier and Allyson Purpura (Champaign: Krannert Art Museum and Kinkead Pavilion, University of Illinois at Urbana-Champaign, 2018), 289–309.

48. Ibid.

49. Lois Sherr Dubin, *The History of Beads: From 30,000 B.C. to the Present* (New York: Abrams, 2009), 147.

50. Bouttiaux, *African Costumes and Textiles*, 231.

51. Gillow, *African Textiles*, 216.

52. Ibid., 222.

53. Gary Van Wyk, "Illuminated Signs: Style and Meaning in the Beadwork of the Xhosa- and Zulu-Speaking Peoples," *African Arts* 36, no. 3 (2003): 19.

54. Gillow, *African Textiles*, 216.

55. John Pemberton, *African Beaded Art: Power and Adornment* (Northampton, MA: Smith College Museum of Art, 2008), 175.

56. Ibid.

Gender

1. John Gillow, *African Textiles: Color and Creativity across a Continent* (New York: Thames & Hudson, 2009), 144.

2. Ibid.

3. "Raf-Raf Bridal Outfits (Tunisia)," Textile Research Center Leiden, accessed March 29, 2019, https://trc-leiden.nl/trc-needles/regional-traditions/middle-east-and-north-africa/pre-modern-middle-east-and-north-africa/raf-raf-bridal-outfits-tunisia.

4. Christopher Spring and Julie Hudson, *North African Textiles* (Washington, DC: Smithsonian Institution Press, 1995), 52.

5. "Raf-Raf Bridal Outfits (Tunisia)," Textile Research Center Leiden.

6. Spring and Hudson, *North African Textiles*, 49.

7. Cynthia J. Becker, *Amazigh Arts in Morocco: Women Shaping Berber Identity* (Austin: University of Texas Press, 2010), 3.

8. Robert K. Liu and Liza Wataghani, "Moroccan Folk Jewelry," *African Arts* 8, no. 2 (1975): 34.

9. Ibid., 33.

10. Ibid.

11. Becker, *Amazigh Arts in Morocco*, 45.

12. Ibid., 119.

13. Fatima Sadiqi, "The Role of Moroccan Women in Preserving Amazigh Language and Culture," *Museum International* 59, no. 4 (2007): 31.

14. Gillow, *African Textiles*, 120.

15. Ibid.

16. Brinkley Messick, "Subordinate Discourse: Women, Weaving, and Gender Relations in North Africa," *American Ethnologist* 14, no. 2 (1987): 213.

17. Ibid.

18. Cynthia Becker, "Trans-Saharan Aesthetics: Textiles at the Desert Fringe," in *Africa Interweave: Textile Diasporas*, ed. Susan Cooksey (Gainesville: Samuel P. Harn Museum of Art, University of Florida, 2011), 42.

19. Victoria L. Rovine, *Bogolan: Shaping Culture through Cloth in Contemporary Mali* (Bloomington: Indiana University Press, 2008), 17–21.

20. Sarah Brett-Smith, *The Silence of the Women: Bamana Mud Cloths* (Milan: 5 Continents, 2014), illustration 51.

21. Ibid., 187–92.

22. Mary Jo Arnoldi and Christine Mullen Kreamer, "Crowning Achievements: African Arts of Dressing the Head," *African Arts* 28, no. 1 (1995): 31, 34.

23. Gillow, *African Textiles*, 207.

24. Ibid.

25. Duncan Clarke, Bernhard Gardi, and Frieder Sorber, *African Textiles: The Karun Thakar Collection* (Munich: Prestel Verlag, 2015), 226.

26. Marie-Louise Labelle, "Beads of Life: Eastern and Southern African Adornments," *African Arts* 38, no. 1 (Spring 2005): 14.

27. Angela Fisher and Carol Beckwith, *Dinka: Legendary Cattle Keepers of Sudan* (New York: Rizzoli International Publications, 2008), 217.

28. Labelle, "Beads of Life," 14–15.

29. Harold Koda, Virginia-Lee Webb, Eric Kjellbren, Alisa LaGamma, and Emily Martin, "Africa, Oceania, and the Americas," *Metropolitan Museum of Art Bulletin* 59, no. 2 (2001): 75.

30. Fisher and Beckwith, *Dinka*, 39, 200.

31. Donna Klumpp and Corinne Kratz, "Aesthetics, Expertise, and Ethnicity: Okiek and Maasai Perspectives on Personal Ornament," in *Being Maasai: Ethnicity and Identity in East Africa*, ed. Thomas Spear and Richard Waller (Boydell & Brewer, 1993), 197.

32. Pamela McClusky, "Collecting Beads and Wishes for the Future: Ornaments for a Maasai Bride," in *Art from Africa: Long Steps Never Broke a Back* (Seattle: Seattle Art Museum, 2002), 276.

33. Ibid., 205–6.

34. Labelle, "Beads of Life," 19.

35. Klumpp and Kratz, "Aesthetics, Expertise, and Ethnicity," 206.

36. John Gillow, "East Africa," in Gillow, *African Textiles*, 175.

37. Judith von D. Miller, "Art Institutions in East Africa," in *Art in East Africa: A Guide to Contemporary Art* (London: Frederick Muller, 1975), 57.

38. Georges Meurant, *Mbuti Design: Paintings by Pygmy Women of the Ituri Forest* (New York: Thames & Hudson, 1996).

39. Gillow, *African Textiles*, 181–82.

40. Susan Cooksey, "Bark and Raffia Cloth: Interpreting Indigenous Prestige," in Cooksey, *Africa Interweave*, 110; and Gillow, *African Textiles*, 202.

41. William F. Wheeler Jr., "Efe Barkcloth Painting," *African Arts* 29, no. 4 (Autumn 1996): 64.

42. Cooksey, "Bark and Raffia Cloth," 110.

43. Wheeler, "Efe Barkcloth Painting," 64.

44. Ezio Bassani, "A Note on Kongo High-Status Caps in Old European Collections," *RES: Anthropology and Aesthetics*, no. 5 (1983): 75.

45. Phyllis M. Martin, "The Kingdom of Loango," in *Kongo: Power and Majesty*, ed. Alisa LaGamma (New York: Metropolitan Museum of Art, 2015), 64.

46. Mary Jo Arnoldi and Christine Mullen Kreamer, *Crowning Achievements: African Arts of Dressing the Head* (Los Angeles: Fowler Museum of Cultural History, University of California, 1995), 43.

47. Bassani, "Note on Kongo High-Status Caps," 78–79.

48. Gordon D. Gibson and Cecilia R. McGurk, "High-Status Caps of the Kongo and Mbundu Peoples," *Textile Museum Journal* 5, no. 4 (1977): 71.

49. Bassani, "Note on Kongo High-Status Caps," 80.

50. Alisa LaGamma, "Out of Kongo and into the *Kunstkammer*," in LaGamma, *Kongo*, 113.

51. Martin, "Kingdom of Loango," 64.

52. Hildi Hendrickson, "The 'Long' Dress and the Construction of Herero Identities in Southern Africa," *African Studies* 53, no. 2 (1994): 25–26.

53. Jim Naughten, "Portraits," in *Conflict and Costume: The Herero Tribe of Namibia* (London: Merrell Publishers, 2013), 37.

54. Hendrickson, "The 'Long' Dress," 26–27, 33, 45–49.

55. Ibid., 25, 29, 35.

56. Deborah Durham, "The Predicament of Dress: Polyvancy and the Ironies of Cultural Identity," *American Ethnologist* 26, no. 2 (1999): 391–94.

57. Hendrickson, "The 'Long' Dress," 30–31; and Durham, "The Predicament of Dress," 393.

58. Naughten, "Portraits," 67.

59. Hendrickson, "The 'Long' Dress," 27, 31.

60. Aisling Macken, "Discovering the History of a Blanket: Conserving a Ndebele Wedding Blanket," *Textile Conservation* (blog), January 29, 2017, http://textileconservation.academicblogs.co.uk/discovering-the-history-of-a-blanket-conserving-a-ndebele-wedding-blanket/; and Suzanne Priebatsch and Natalie Knight, "Traditional Ndebele Beadwork," *African Arts* 11, no. 2 (January 1978): 26.

61. Priebatsch and Knight, "Traditional Ndebele Beadwork," 25.

62. Ibid.

Generational Conflict and Continuity

1. Lois Sherr Dubin, *The History of Beads: From 30,000 B.C. to the Present* (New York: Abrams, 2009), 144, 149.

2. Cynthia J. Becker, *Amazigh Arts in Morocco: Women Shaping Berber Identity* (Austin: University of Texas Press, 2010), 118.

3. Ibid., 51.

4. Ibid., 118.

5. Ibid.

6. Robert K. Liu and Liza Wataghani, "Moroccan Folk Jewelry," *African Arts* 8, no. 2 (1975): 33.

7. Becker, *Amazigh Arts in Morocco*, 118.

8. Doran H. Ross, "Footwear," in *Berg Encyclopedia of World Dress and Fashion*, ed. Joanne B. Eicher and Doran H. Ross (Oxford: Berg Publishers, 2010), 116.

9. Doran H. Ross, *Wrapped in Pride: Ghanaian Kente and African American Identity* (Los Angeles: Fowler Museum of Cultural History, University of California, 1998), 19.

10. Victoria L. Rovine, "West African Embroidery: History, Continuity, and Innovation," in *Africa Interweave: Textile Diasporas*, ed. Susan Cooksey (Gainesville: Samuel P. Harn Museum of Art, University of Florida, 2011), 58.

11. Christa Clarke, *Power Dressing: Men's Fashion and Prestige in Africa* (Newark: Newark Museum Association, 2005), 8.

12. Victoria L. Rovine, "Everyday Endeavor: Textiles," *Art & Life in Africa*, ed. Christopher Roy (Iowa City: University of Iowa Stanley Museum of Art), 1.

13. Rovine, "West African Embroidery," 59.

14. Clarke, *Power Dressing*, 8.

15. Ibid., 8–9; and Rovine, "Everyday Endeavor," 2.

16. Tunic (*Jibbeh*), Sudan, The Metropolitan Museum of Art, New York, 1993.370.

17. Gabriel R. Warburg, "From Sufism to Fundamentalism: The Mahdiyya and the Wahhabiyya," *Middle Eastern Studies* 45, no. 4 (2009): 661, 662, 668, 669.

18. "Mahdist Tunic (Jibbeh)," in "Recent Acquisitions, A Selection: 1993–1994," *Metropolitan Museum of Art Bulletin* 52, no. 2 (Fall 1994): 80.

19. Marie-Thérèse Brincard, ed., *Kuba Textiles: Geometry in Form, Space, and Time* (New York: Neuberger Museum of Art, 2015), 12.

20. Ibid., 30.

21. Georges Meurant, *Shoowa Design: African Textiles from the Kingdom of Kuba* (New York: Thames & Hudson, 1986), 129.

22. Suzanne Preston Blier, "Kongo and Kuba: The Art of Rulership Display," in *The Royal Arts of Africa: The Majesty of Form* (London: Laurence King, 2012), 245.

23. Brincard, *Kuba Textiles*, 31.

24. Meurant, *Shoowa Design*, 245.

25. Hildi Hendrickson, "Namibia," in Eicher and Ross, *Berg Encyclopedia*, 33; and Ettagale Blauer, *African Elegance* (New York: Rizzoli International Publications, 1999), 164–65.

26. Blauer, *African Elegance*, 162.

27. Ibid., 132.

28. Ibid., 165.

29. D. P. Crandall, "The Role of Time in Himba Valuations of Cattle," *Journal of the Royal Anthropological Institute of Great Britain and Ireland* 4, no. 1 (1998): 101–14.

30. Ibid., 106.

31. Elizabeth Ann Schneider, "Ndebele Umndwana: Ndebele Dolls and Walls," in *Evocations of the Child: Fertility Figures of the Southern African Region*, ed. Elizabeth Dell (Cape Town: Human & Rousseau, 1998), 139.

32. Suzanne Priebatsch and Natalie Knight, "Traditional Ndebele Beadwork," *African Arts* 11, no. 2 (January 1978): 24.

33. Schneider, "Ndebele Umndwana: Ndebele Dolls and Walls," in Dell, *Evocations of the Child*, 145–47.

34. Priebatsch and Knight, "Traditional Ndebele Beadwork," 24.

35. Marie-Louise Labelle, "Beads of Life: Eastern and Southern African Adornments," *African Arts* 38, no. 1 (Spring 2005): 23–31, 33.

36. Carol Boram-Hays, "Borders of Beads: Questions of Identity in the Beadwork of the Zulu-Speaking People," *African Arts* 38, no. 2 (Summer 2005): 45.

37. Ibid., 46; and Frank Jolles, "Traditional Zulu Beadwork of the Msinga Area," *African Arts* 26, no. 1 (January 1993): 53.

38. Boram-Hays, "Borders of Beads," 46.

39. Ibid., 47.

40. Anitra Nettleton, "Life in a Zulu Village: Craft and the Art of Modernity in South Africa," *Journal of Modern Craft* 3, no. 1 (March 2010): 62.

41. Mary Axworthy and Beth Baniadam, "Selected Objects: Contemporary," in *Asking for Eyes: The Visual Voice of Southeast Africa*, ed. Teri L. Sowell and Mary Axworthy (San Diego: University Art Gallery, San Diego State University, 2004), 89.

42. Nettleton, "Life in a Zulu Village," 66.